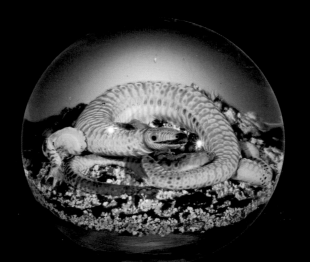

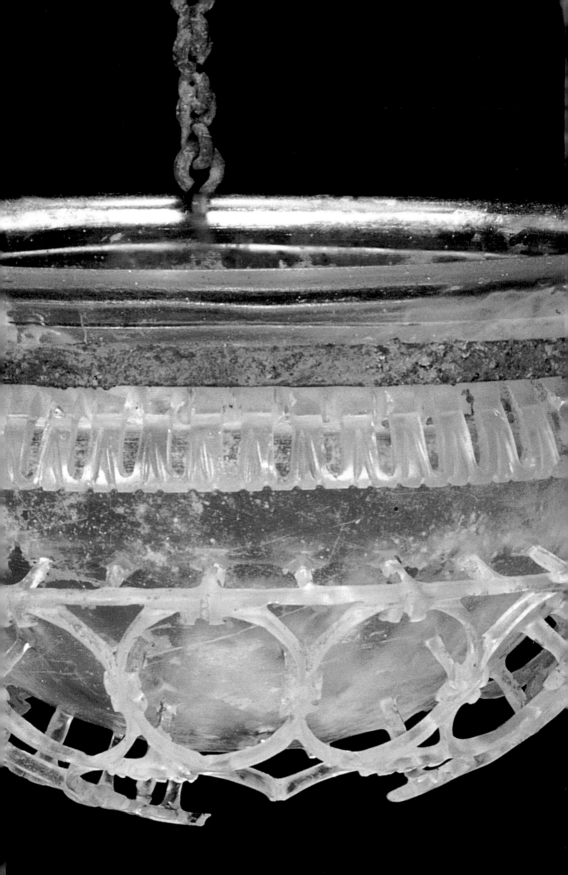

LOOKING AT
GLASS

A GUIDE TO TERMS, STYLES, AND TECHNIQUES

CATHERINE HESS KAROL WIGHT

THE J. PAUL GETTY MUSEUM LOS ANGELES

© 2005 J. Paul Getty Trust

Getty Publications
1200 Getty Center Drive, Suite 500
Los Angeles, California 90049-1682

www.getty.edu

Christopher Hudson, Publisher
Mark Greenberg, Editor in Chief

This book contains extensive quotations from *Glass: A
Pocket Dictionary of Terms Commonly Used to Describe
Glass and Glassmaking* by David Whitehouse (© 1993 The
Corning Museum of Glass). We express our gratitude to
Dr. David Whitehouse and the Corning Museum for their
cooperation in this publication.

Front cover: Detail of prunted beaker. See p. 71.

Half-title page: The Houghton Salamander. See p. 12.

Frontispiece: Detail of cage cup. See p. 22.

Page viii: Detail of mold-blown amber glass beaker with
"lotus buds." Roman, first century A.D. From the eastern
Mediterranean. JPGM 2003.320.

Page 90: Detail of mosaic-glass bowl. First century B.C.
From the eastern Mediterranean. JPGM 2003.246.

Page 92: Detail of mosaic agate bowl. End of first century
B.C.–first century A.D. From the eastern Mediterranean.
JPGM 2003.253.

Back cover: Detail of Jack-in-the-pulpit vase. See p. 47.

Library of Congress Cataloging-in-Publication Data

Hess, Catherine, 1957-
 Looking at glass : a guide to technical terms / Catherine Hess, Karol Wight.
 p. cm. — (Looking at)
 ISBN-10: 0-89236-750-4 (pbk.)
 ISBN-13: 978-0-89236-750-4 (pbk.)
 1. Glass — Dictionaries. I. Wight, Karol, 1958- II. Title. III. Series.
 TP788.H42 2005
 748'.03 — dc22
 2004024494

Contents

Preface

This book is one of a series of *Looking at . . .* guides published by the J. Paul Getty Museum to help our visitors better understand how the works of art in our collections were made. This volume focuses on technical terms associated with the production of glass from antiquity to the present day. Numerous other glossaries and dictionaries that relate to glass and glass production have appeared before this volume. These frequently are glossaries or appendices in collection catalogues and focus on the works discussed in those volumes. Perhaps the most useful modern English-language dictionary of glass terms was published by The Corning Museum of Glass in 1993. *Glass: A Pocket Dictionary of Terms Commonly Used to Describe Glass and Glassmaking* was developed from a catalogue glossary that accompanied the exhibition *Treasures from the Corning Museum of Glass*, held in Yokohama, Japan, in 1992. *Glass* comprises technical production terms, definitions of types of glass, and explanations of vessel shapes.

In keeping with the format of other works in the *Looking at . . .* series, the contents of *Looking at Glass* are more focused than those of *Glass*; there are no descriptions of vessel shapes, for example, and some technical definitions are omitted because they are not reflected by pieces within the Getty Museum's collections. The authors are grateful to colleagues at The Corning Museum of Glass, particularly David Whitehouse, Executive Director of The Corning Museum of Glass and compiler of *Glass*, for allowing twenty-five definitions to be reproduced directly from that work.

The terms in *Looking at Glass* are arranged alphabetically. Words that are set in small capitals are terms whose definitions appear elsewhere in the book. Some terms are included as subdefinitions; the entry "vessel components," for example, contains the terms "bowl," "foot," "knop," and "stem." In other instances, when terms seemed redundant or derivative, they were combined into a single section: "Grinding," for example, can be found under "cutting" and is cross-referenced to that section. Non-English terms are italicized and their source language identified.

The works illustrated in this volume come from the collections of the J. Paul Getty Museum (JPGM), The Corning Museum of Glass (CMOG), and the Victoria and Albert Museum (V&A). The authors are grateful to these institutions for reproduction permissions. Illustration captions identify the institutions to which the objects belong.

Acknowledgments

Every book is the result of a creative process that begins with its authors, but ends with the participation and guidance of numerous other individuals. At the Getty, the authors wish to thank Marion True, Curator of Antiquities and Trust Coordinator for Villa Programs, and Scott Schaefer, Curator of Paintings, for their support while the book was being prepared. We also thank Mark Greenberg and Benedicte Gilman of Getty Publications for their assistance and guidance in seeing this volume through to publication. Jack Ross, Ellen Rosenbery, Anthony Peres, and Columbine Bloodworth in the Department of Photographic Services took the beautiful photos of Getty objects. One of the illustrations was provided by the Department of Manuscripts, and we thank Thomas Kren, Curator of Manuscripts, and Kurt Barstow, Associate Curator of Manuscripts, for their assistance and permission to reproduce this image. Other illustrations are from the holdings of the Special Collections at the Getty Research Institute, and we thank Wim de Wit for his assistance in providing them.

At The Corning Museum of Glass, we are indebted to David Whitehouse, Executive Director; William Gudenrath, Director of the Studio; and Jill Thomas-Clark, Rights and Reproductions Coordinator, for their assistance and advice. At the Toledo Museum of Art, we are grateful to Jutta-Annette Page, Curator of Glass. At the Victoria and Albert Museum, we thank Mary Butler, Head of Publications; Reino Liefkes, Senior Curator, Ceramics and Glass; and Martin Durrant, Picture Librarian, for their help. We are also grateful for the insightful and helpful comments provided by our anonymous reviewers. Finally, we thank our families for their support and encouragement and for granting us time away from them during evenings and on weekends, while on vacation and at home, so that we could prepare this volume.

Catherine Hess
Karol Wight

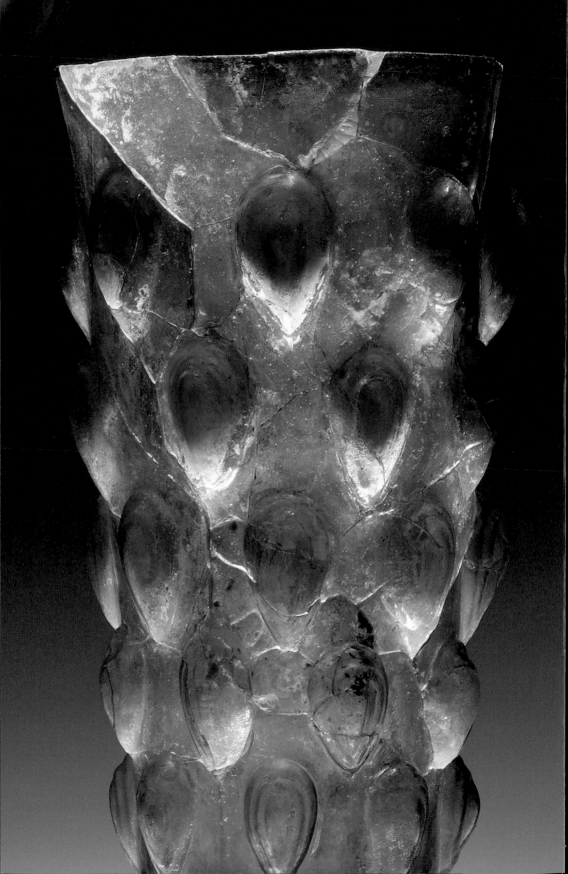

Introduction

The technique of making glass and the process of forming it into useful objects have been known since the end of the third millennium B.C. and were recorded in written form in the succeeding millennium. The origins of glass production occurred in the eastern Mediterranean, most likely Mesopotamia, around 2500 B.C. At that time, vitreous glazes were being used to color objects made of clay or faïence (a ceramic material containing a large proportion of quartz), and the discovery of glassmaking appears to have been an accidental result of that process. Beads, inlays, cylinder seals, and rods used for architectural decoration were among the earliest objects made of glass. Vessels, however, were not produced for another five or six hundred years. Documentation of technical information appears in cuneiform texts from the middle of the second millennium B.C. and refers to colored glasses intended to imitate precious stones. These texts carefully distinguish between the genuine precious stone and its glass imitation. Later cuneiform tablets from the library of the Assyrian king Assurbanipal in Nineveh record instructions to glassmakers for the making of colored glass. Thus from the earliest periods of what might be called the glass industry, written records describe its qualities and its manufacture. The written records of ancient cultures contemporary to those of Mesopotamia, namely Egyptian, and later cultures also make reference to glass and glassmaking.

Until it was discovered in the first century B.C. that glass could be inflated at the end of a metal tube, all glass vessels were made by casting or core forming, which involves gathering hot glass around a core that is later removed. Thus for centuries the processes used to make glass were time-consuming and labor intensive. The resulting objects were small, rare, and considered luxury items. But by the end of the first century B.C., thanks to glass blowing, glass was beginning to be mass-produced and became an affordable commodity that people of all socioeconomic classes could use and enjoy. Glass began to replace fired clay vessels in everyday life. Latin authors mention glass vessels in their writings in a manner that indicates that these containers were becoming more commonplace. The ease of inflation allowed glassmakers of the Roman period to develop new techniques to shape and decorate their vessels, and these techniques were used for centuries until the advent of mechanized glassmaking that accompanied the Industrial Revolution. Literary sources continued to document glassmaking in the post-antique period. In the Middle Ages a monk who was also a practicing glassmaker was responsible for writing in the first half of the twelfth century the earliest treatise on glassmaking, *De diversis artibus* or *Schedula*

diversarum artium (On the various arts). Known as Theophilus Presbyter, the author may be identifiable as the German metalworker Roger of Helmarshausen. Venetian glassmaking is well documented from the thirteenth century onward. In 1556 the multivolume work of Georgius Agricola, *De re metallica* (On metallurgy), was posthumously published. The final volume of this study of metallurgy and mineralogy concerned the production of glass. In 1612 Antonio Neri published his *L'Arte vetraria* (The art of glassmaking). In a manner similar to Agricola's, Denis Diderot and Jean Le Rond d'Alembert's *Encyclopédie, ou, Dictionnaire raisonné des sciences, des arts, et des métiers* (Paris, 1765–) contains information and illustrations on glassmaking in volume 10. These illustrated publications tell us that the tools used by ancient glassmakers, like the methods used to make glass, also remained largely unchanged for centuries. Advances were made in glass kiln and furnace designs, and glassmakers facilitated their manufacturing process by developing the chair or workbench used by the master craftsman when creating an object.

The glass in the permanent collections of the Getty Museum ranges in date from the thirteenth century B.C. to the late seventeenth century A.D. The ancient glass is primarily Roman, while the later European glass was made in important glass-production centers in Italy, Germany, Bohemia, the Netherlands, Silesia, and Austria. Not intended to form a comprehensive survey, the Getty Museum's collections are strong in two important phases in the history of glass: antiquity and the Renaissance and Baroque periods. It is hoped that this volume will enable our visitors better to understand the production techniques used to make our objects, and thus enjoy them all the more.

Abbreviations

ca.	circa
cm	centimeter
CMOG	The Corning Museum of Glass, Corning, New York
Diam	diameter
fig.	figure
fl.	flourished
GRI	Getty Research Institute, Los Angeles
H	height
in.	inch(es)
JPGM	The J. Paul Getty Museum, Los Angeles
L	length
max.	maximum
ms.	manuscript
pl.	plate, plural
v	verso
V&A	The Victoria and Albert Museum, London
vol.	volume
W	width

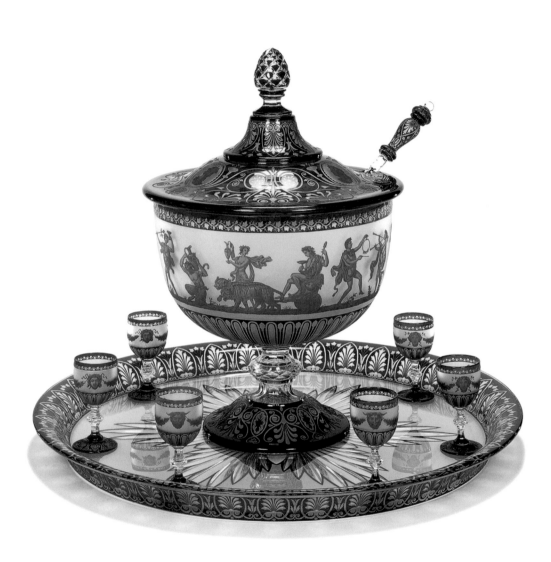

ACID ETCHING
Punchbowl set. Colorless and transparent blue glass; BLOWN, CASED, and acid etched. H: 56.5 cm (22¼ in.).
France, Cristalleries de Baccarat, before 1867. CMOG 67.3.41, gift of Mrs. Charles K. Davis.

Glossary

ABRASION

GRINDING shallow decoration with a wheel or tool onto the surface of a vessel. The resulting matte finish in the decorated areas is usually left unpolished.

Rotary polishing: grinding or polishing an object with tools and an abrasive while it is turned on a LATHE.

Sandblasting: removing glass from or creating a matte finish on the surface of a vessel by striking it with fine grains of sand or other abrasives, such as silicon carbine and aluminum oxide grit, which are propelled by compressed air.

ACID ETCHING

Using hydrofluoric acid to alter the surface of glass. Etching can be used to create a matte surface, to roughen the surface, to polish it, or to decorate it. The glass is first covered with a waxlike acid-resistant substance (known as *resist*) through which the area or pattern to be etched is incised with a sharp tool. Diluted hydrofluoric acid and potassium fluoride are then applied to the exposed areas of the glass until the desired result is achieved. An effect similar to WEATHERING can be achieved by exposing glass to fumes of hydrofluoric acid to create a matte surface.

Acid polishing: creating a polished surface by dipping an object, usually of cut glass, into a mixture of hydrofluoric and sulfuric acids.

Acid stamping: using a stamplike device to acid etch a trademark or signature onto glass after it has been ANNEALED.

Hydrofluoric acid: a highly corrosive acid that attacks glass and SILICATES like glass. Glass dissolves in pure hydrofluoric acid, leaving an acid-polished surface.

ACID POLISHING (see ACID ETCHING)

ACID STAMPING (see ACID ETCHING)

AIR TRAPPING (see BUBBLE)

ALKALI

A soluble salt leached from the ashes of burned plants that contain potassium or sodium carbonate and called POTASH or *soda ash*, respectively (see SODA). It is one of the essential ingredients of glass, generally accounting for about 15 to 20 percent of the BATCH. The alkali is a FLUX, which reduces the melting point of SILICA (in the form of SAND or, less often, flint), the major constituent of glass. Otherwise, the temperature at which the silica melts would be too high to be practical or commercially viable.

ANNEALING

The process of heat treating and slowly cooling a completed object in a heated chamber known as a *lehr* (or *leer*) or *garage* in order to allow the stresses built up in the glass during manufacture to dissipate without deforming the object. The lehr is either a chamber connected to the main glass FURNACE or a sepa-

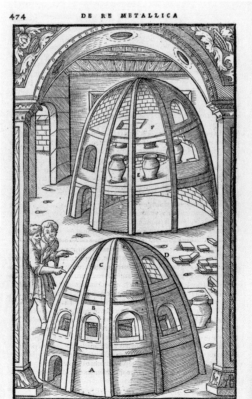

ANNEALING
The lehr is the top chamber, marked *F*, in the upper illustration. From Georgius Agricola, *De re metallica* (Basel, 1556), p. 474. Los Angeles, Research Library, GRI no. 84-B21868. Photo: GRI.

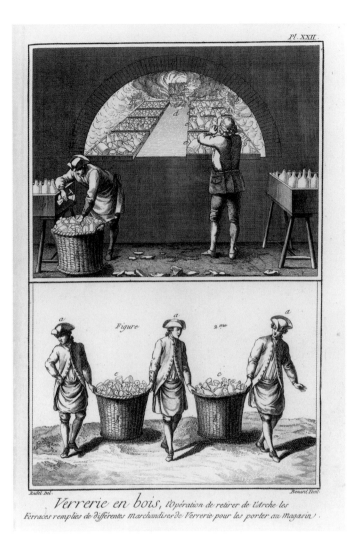

Radel Del. *Benard Fecit*

Verrerie en bois, l'opération de retirer de l'Arche les Ferraces remplies de differentes marchandises de Verrerie pour les porter au Magasin.

ANNEALING
The upper image illustrates a so-called tunnel lehr. Workmen are shown taking bottles from this cooling chamber and placing them in baskets for transport to market. From Denis Diderot and Jean Le Rond d'Alembert, *Recueil des planches, sur les sciences et les arts liberaux et les arts méchaniques, avec leur explicacion* (Paris, 1772), vol. 10, pl. 22, fig. 1. Los Angeles, Research Library, GRI no. 84-B31322. Photo: GRI.

rate construction. This is a critical step in glassmaking, for if the hot glass object is allowed to cool too quickly, it will be highly strained by the time it reaches room temperature; indeed, it may spontaneously break during the cooling process. Highly strained glass breaks easily if subjected to mechanical or thermal shock. The strain is caused by different parts of the glass cooling and hardening at different rates. To equalize the cooling process, the glass is initially heated to a uniform temperature and then allowed to cool uniformly in the lehr.

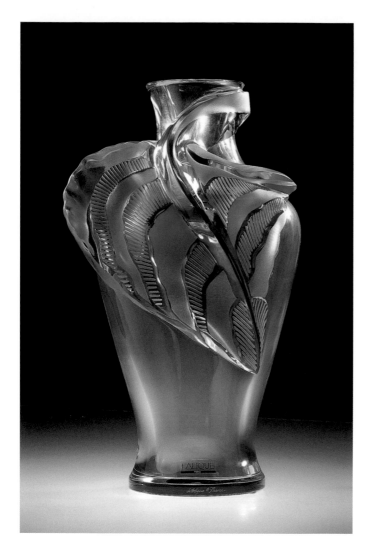

APPLIED DECORATION

Heated glass elements applied and thereby fused to a hot glass object during manufacture. The elements are either left in relief or are marvered until they are flush with the surface (see TOOLS). The latter is referred to as marquetry decoration because of the INLAID effect. See also PICK-UP DECORATION and TRAILING.

AT-THE-FIRE (see REHEATING)

AT-THE-FLAME (see FLAMEWORK)

AVENTURINE (from the Italian *avventura*, for "chance")

Translucent brownish (copper aventurine) or green (chrome aventurine) glass with glittering metallic INCLUSIONS. It was first made by chance, *per avventura*, by a Muranese glassmaker in the early sixteenth century. To purposely create the glinting effect, flakes of gold were added to the glass mixture; later, copper or chromic oxides were used. The gemstone mineral of the same name — usually a variety of quartz scattered with sparkling mica — displays a similar effect.

AVENTURINE
Beaker of chalcedony glass. Transparent dark ruby agate, or *Schmelz*, glass with green, blue, and brown streaks; BLOWN with inlaid decoration. H: 8.9 cm (3½ in.). Italy, Venice, eighteenth century. CMOG 53.3.46.

BAR

A single piece of glass formed by fusing together several CANES or rods to create a certain pattern or image when the bar is cut into cross-sections. A bar can be cut into numerous slices, all with the same design, to be used as INLAYS or applied decoration, or in making MOSAIC GLASS vessels.

BARILLA

A maritime plant called *saltwort* or *glasswort* (*Salicornia europaea* or *Salicornia herbacea*) that grows extensively in Spain, Sicily, and the Canary Islands. The term also refers to the impure ALKALI, or POTASH, produced by burning this maritime plant—and other related plants, such as kelp—in dried form. This material was an important commodity used in the manufacture of SODA and soap, as well as glass. Barilla makes the glass mixture especially ductile: elastic enough to produce shapes that are thin, light, and elaborate.

BATCH

The mixture of raw materials to make glass. The ingredients—generally SILICA (from SAND, flint, or quartz), an ALKALI (in the form of soda ash [see SODA] or POTASH), and LIME (as calcium-containing impurities or calcined limestone)—are heated in a CRUCIBLE, or pot made of fireclay. Other elements, such as CULLET and METALLIC OXIDE, can be added to the pot to form part of the batch. The mixture in a molten state is called the MELT, although *batch* is commonly used to denote the same thing.

BATTLEDORE (see TOOLS)

BIT IRON (see TOOLS)

BLANK

A cooled glass object, usually a vessel, that will be further formed or decorated, often using cold-working techniques such as CUTTING.

BLOBBING

Decorating glass by dropping blobs of molten glass onto the surface. The blobs are often of a different color or colors than the glass used for the vessel to which they are applied. The blobs can be left either in relief or flattened onto the surface of the vessel by marvering (see TOOLS). See also PICK-UP DECORATION.

BLOCK (see TOOLS and illustration for BLOWING)

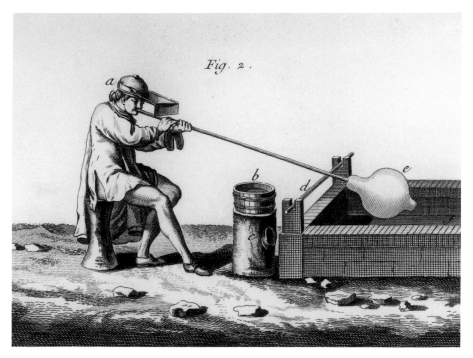

BLOWING

The glassblower is furnished with a protective visor for his eyes and uses an iron rod (*d*) to help form and sustain the weight of the PARISON (*e*) that he is inflating. He also has a bucket of water on a tree stump at hand (*b–c*). A tub of water can be used for several purposes. It can hold rags to help cool the iron if it gets too hot, a wooden block (see TOOLS) can be kept in the water to keep it from combusting when used to help form a GATHER of hot glass, and tools can also be dipped in this water to assist in CRACKING OFF. From Denis Diderot and Jean Le Rond d'Alembert, *Recueil des planches, sur les sciences et les arts liberaux et les arts méchaniques, avec leur explicacion* (Paris, 1772), vol. 10, pl. 11 L, fig. 2. Los Angeles, Research Library, GRI no. 84-B31322. Photo: GRI.

BLOWING

The technique of forming an object by inflating a gob of molten glass gathered on the end of a blowpipe (see TOOLS). To gather a gob, the "nose" of the blowpipe (the conical end opposite the mouthpiece) is preheated to allow the glass to adhere to it, dipped in molten glass inside the FURNACE, rotated, and withdrawn from the furnace. The GAFFER shapes the gob (using either a MARVER, a BLOCK, or a pad of damp paper) and blows through the pipe, slightly inflating the gob to form an initial BUBBLE, or PARISON. Free-blown glass is shaped by manipulating the parison using gravity, centrifugal force (by swinging the pipe), and TOOLS such as jacks, pincers, or shears. By contrast, mold-blown glass is shaped by inflating the parison in a mold. See also MOLD BLOWING.

BLOWPIPE, BLOWING IRON (see TOOLS)

BORSELLA (see TOOLS)

BOWL (see VESSEL COMPONENTS)

BOW LATHE (see LATHE)

BRILLIANT CUTTING (see CUTTING)

BROAD GLASS (see WINDOW)

BROKEN-SWIRL RIBBING (see MOLD BLOWING)

BUBBLE

A pocket of gas trapped in glass during manufacture. The term is used for both bubbles trapped accidentally in the BATCH during the melting process and those introduced intentionally, including the initial phase of inflation as well as very small bubbles of gases released from the batch during FOUNDING (known as SEEDS). Intentional bubbles (known as *air traps* or *beads*) are used, for example, in the decoration of stems (see VESSEL COMPONENTS) and include air twists (elongated, twisted bubbles) and teardrops (tear-shaped bubbles).

BULL'S EYE (see WINDOW)

CAGE CUP (see CUTTING)

CAKE

A flat tablet of glass that was produced in eighteenth-century Murano to be sold commercially, probably for making decorative colored enamels. These ingots — often impressed with the glassmaker's mark — could be transparent but most often were opaque and brilliantly colored.

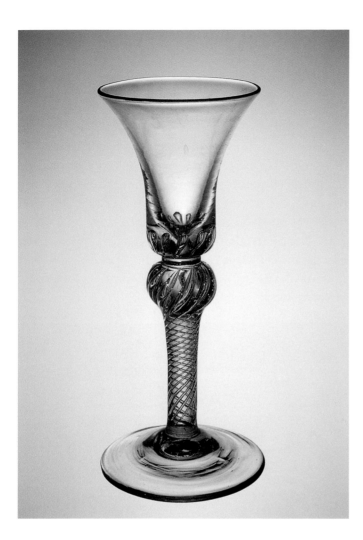

Bubble
Wineglass. Colorless
LEAD GLASS; BLOWN.
H: 17 cm (6¾ in.).
England, ca.
1750–1760. CMOG
79.2.336, gift of The
Ruth Bryan Strauss
Memorial Foundation.

Cake
ENAMELer's opaque
blue glass disk.
Bertolini Brothers.
Italy (Venice), ca. 1740.
V&A C.178–1925.

***CALCEDONIO* (CHALCEDONY GLASS)** (see MARBLED GLASS)

CALIPERS (see TOOLS)

CAMEO GLASS

Glass made of two or more layers of glass of different colors. During manufacture, the primary layer is covered with one or more layers of contrasting color, usually by ENCASING. The outer layers are carved, CUT, ENGRAVED, sandblasted (see ABRASION), or ACID ETCHED to produce a design in relief, and the primary layer serves as the background color for the design. The glass used to make the layers was generally softer in order to facilitate the creation of the relief design. The first cameo glass objects (vessels, gems, plaques, and INLAYS) were made by the ancient Romans. The majority of cameo vessels are made of only two layers of glass, usually white over blue, but some were produced with up to seven layers.

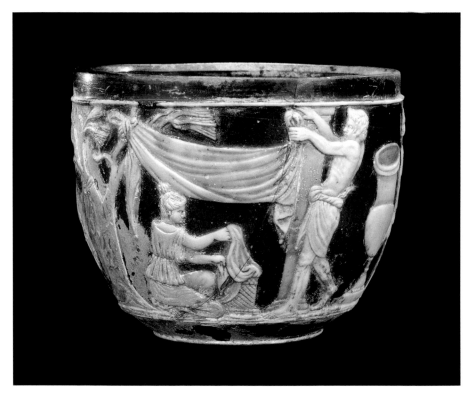

CAMEO GLASS
Ritual scene with Satyr, canopy, and young female attendant. *The Morgan Cup.* Opaque white over
translucent deep blue glass; BLOWN, CASED, carved, ground, and POLISHED. H: 6.2 cm (2½ in.).
Italy (Rome), first half of first century A.D. CMOG 52.1.93, gift of Arthur A. Houghton, Jr.

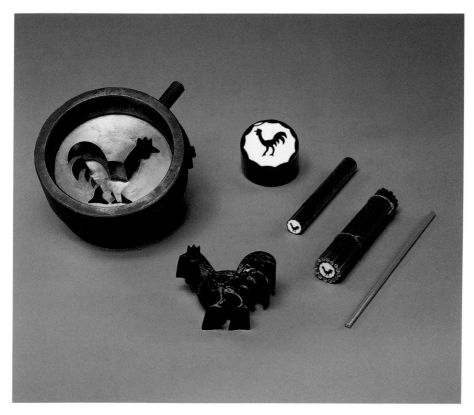

CANE

Some of the tools and steps used to construct a rooster cane are illustrated here. An iron MOLD is used to make a cane with the figure of a rooster. This is then ENCASED in white glass, and the cane dipped into a faceted mold. The cane is then encased in dark blue and dipped into a circular mold. Rods are attached to either end of the cane, and the cane is pulled until the rod has reached the desired diameter. At this point, additional decorative borders can be added by surrounding the cane with red or other COLORED rods and FUSED. It can then be pulled even further to create a smaller cane. Iron mold; opaque black, white, transparent to translucent polychrome glass. Mold: H: 7.8 cm (3⅛ in.). France, Compagnie des Cristalleries de Baccarat, 1983. CMOG 88.3.212; 83.7.5, gift of Compagnie des Cristalleries de Baccarat.

CANE

A thin glass rod, usually monochrome, or a composite rod consisting of groups of single glass rods of different colors bundled together and FUSED to form a polychrome design that is visible when seen in cross-section. Cut segments of cane are used in the manufacture of MOSAIC GLASS and MILLEFIORI. Canes with decorative finials were used in antiquity as perfume dippers and for stirring. See also BAR.

CARVING (see CUTTING)

CASING

Applying one layer of glass onto the inner surface of a preformed cup made of glass of a different color. Also known as *inside casing* or *cup-overlay*. The two components adhere and are then inflated together. Sometimes the outer layer is CUT or ACID ETCHED to create CAMEO GLASS.

Encasing: covering a vessel or object, such as a paperweight, with a layer of colorless glass. Scholars believe that an encasing technique was used to create ancient Roman cameo glass.

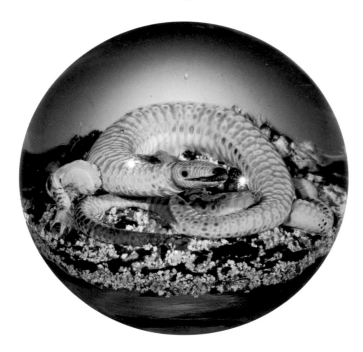

CASTING

A term frequently used to describe a number of techniques used to form glass vessels or objects in a mold (see MOLDING).

Lost wax casting: a molding process adapted from metalworking. The object to be fashioned in glass is made first out of wax. The wax model is completely covered in clay or plaster and then heated. The wax melts and is released from the covering material through gates (holes), also made of wax, which are attached to the wax model before covering and heating. After all of the wax has been released, the clay or plaster dries and becomes rigid. This serves as the mold into which hot, powdered, or chipped glass is introduced through the gates or an opening in the top. If powdered or chipped glass is

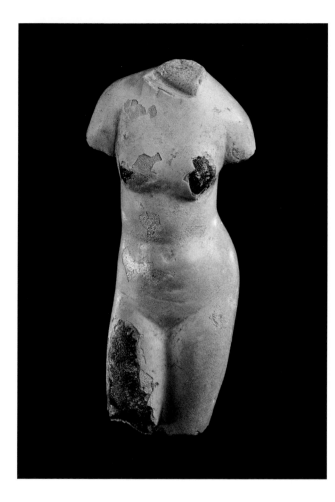

used, the mold is heated in order to fuse the contents. After ANNEALING, the mold is removed from the object, which is then finished by CUTTING, FIRE POLISHING, or ACID ETCHING.

CASTING OFF

An alternate method used instead of SHEARING to separate hanging TRAILS from the body of a vessel. After trails attached to a GATHERING IRON have been applied to the vessel's body, they are separated by pulling away the gathering iron, allowing the unwanted portion to elongate and thin (see TOOLS). The elongated trail is then touched to the hot trail on the vessel body and gently pulled away. The reheating of the elongated trail allows it to become detached. Evidence of this technique is often seen in Roman glass, where it was used for detaching handles and PRUNTS.

CHAIR

> The workbench used by the GAFFER while forming a glass object. Usually, this is a wide bench with arms, on which the gaffer rests the BLOWPIPE with its PARISON of molten glass and rolls it back and forth so that the parison retains its symmetrical shape and stays on the blowpipe during the forming process (see TOOLS). The term can also refer to the team of glassworkers who assist the gaffer.

CHALK GLASS (SODA-POTASH GLASS)

> A colorless glass containing chalk: a soft rock consisting of calcium carbonate that served as an alternative to LIME in stabilizing the glass mixture. Developed in Bohemia in the late seventeenth century, chalk glass could be used to make vessels with thick walls that were strong enough to handle elaborate ENGRAVING.

CHEMICAL OXIDATION (see OXIDIZING ATMOSPHERE)

CLAMP (see TOOLS)

CLAPPER (see TOOLS)

COLD PAINTING

> Decorating an object by applying paint (pigments suspended in resins, alcohol, or oils) to its surface. This is in contrast to ENAMELING, in which powdered glasses of various colors (METAL OXIDES and FRIT) are fired onto the surface by heating. Because it is not fused to the surface, as enamels are, cold-painted decoration can be worn away with handling.

COLLAR

> A band of glass attached to the rim of a vessel. On bottles, the collar is used to hold the cork.

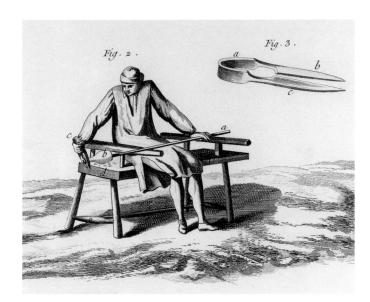

CHAIR
The craftsman is sitting
on a chair (d) and us-
ing its arms to support
the PONTIL (a) that he
rolls back and forth
while he forms the neck
of the bottle (b) with
jacks (c) (see TOOLS).
From Denis Diderot
and Jean Le Rond
d'Alembert, *Recueil
des planches, sur les
sciences et les arts
liberaux et les arts
méchaniques, avec leur
explicacion* (Paris,
1772), vol. 10, pl. 6,
fig. 2. Los Angeles,
Research Library,
GRI no. 84-B31322.
Photo: GRI.

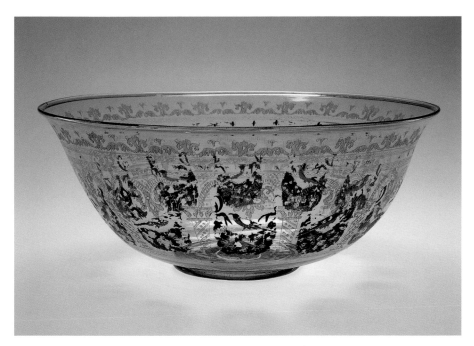

COLD PAINTING

The decoration depicts a diamond-point ENGRAVED arcade. Between the columns, suspended by
sashes, are swags of foliage and pearlike fruit in green and gold on which red, black, and white
goldfinches are perched. This painted decoration is hard to read because it was applied with cold
paint (and, so, was not FUSED to the surface) and has been largely worn away. BOWL, *FAÇON
DE VENISE*. H: 16.5 cm (6⁵⁄₁₆ in.), Diam (at lip): 40.4 cm (15¹⁵⁄₁₆ in.). Austria (Innsbruck),
1570–1591. JPGM 84.DK.653.

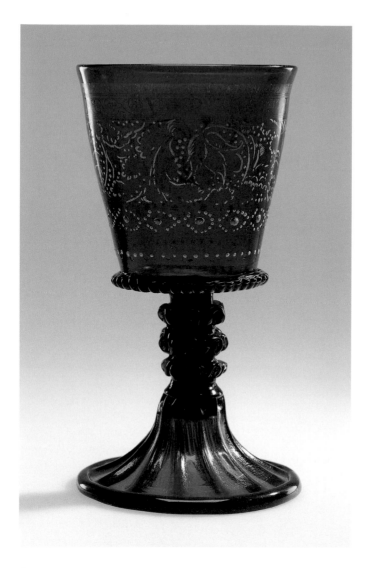

COLORED GLASS

Glass that is colored either by impurities in the basic ingredients in the BATCH (so-called natural glass, usually tinged green or yellow) or by adding minerals or other elements to impart a specific color. In antiquity, for example, copper was added to make red, green, or blue; manganese made purple, brown, or black; and cobalt produced a deep blue. Three main processes were used to color glass: a METALLIC OXIDE could be dissolved in the batch to create the same color throughout, a dispersion of a substance in a colloidal state could be added to the batch (see DICHROIC GLASS), or particles of pigments could be suspended in the batch to form opaque colors.

COMBED DECORATION (see COMBING)

COMBING

Decorating a glass vessel with a zigzag, wavy, festooned, or feathery pattern of two or more colors by applying thin TRAILS of glass of a contrasting color to the glass body. The trails are dragged at right angles with a hooked or pointed tool to achieve the desired pattern, either before or after MARVERING the trail into the body (see TOOLS).

Combed decoration: the patterns resulting from combing.

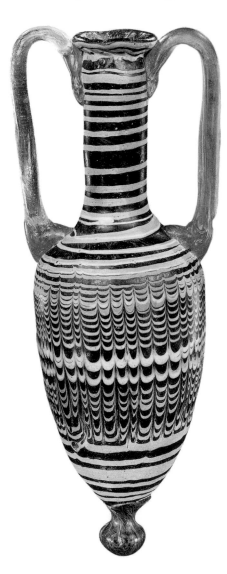

COMBING
Amphoriskos (jar with two handles). Transparent to opaque polychrome glass; CORE formed, APPLIED handles. H: 24.0 cm (9½ in.). Eastern Mediterranean, possibly Cyprus, second–first century B.C. CMOG 55.1.62.

CORD

Accidental colorless streaks in glass. Cords are often the result of poorly mixed BATCH.

CORE

A form made of clay and vegetable material and covered with a layer of calcite. The form is built up over the end of a rod and provides the shape for the interior of a small vessel. In pre-Roman times, the core is thought to have been made of animal dung mixed with clay.

Core forming: Making a small vessel by TRAILING or gathering hot glass around a core supported by a rod. After forming, the object—with the rod still attached—is ANNEALED. After annealing and removing the rod, the core is dislodged by scraping it from the interior of the finished vessel.

CORE FORMING (see CORE)

CRACKING OFF

Detaching a glass object from the BLOWPIPE or PONTIL by weakening its join to the rod such as with a trickle of water to create thermal shock or by scoring it with a metal file to create a tiny crack and then gently rapping the object, or the blowpipe or pontil, to break it free (see TOOLS and illustration for BLOWING). The MOIL (see OVERBLOW) is removed from a vessel in the same manner.

CRIMPERS (see TOOLS)

CRISTALLO (Italian, "crystal")

A term first used in Venice in the fourteenth century to describe glass that resembles colorless rock crystal, a variety of quartz prized for its clarity. The creation of *cristallo*—essentially by adding a decolorizing agent—was arguably the greatest achievement of Venetian glassmakers and that upon which the city's great export trade came to be based. Although clear glass had been created by various cultures in antiquity, its production was exclusive to Venice in the fifteenth century. In the sixteenth century, emigrant Venetians transmitted the process to other centers in Europe, such as Bohemia, Austria, Spain, the Netherlands, France, and England. England was very much on the periphery of this phenomenon, while the southern Netherlands (especially Antwerp) had early large-scale production centers. See also FAÇON DE VENISE.

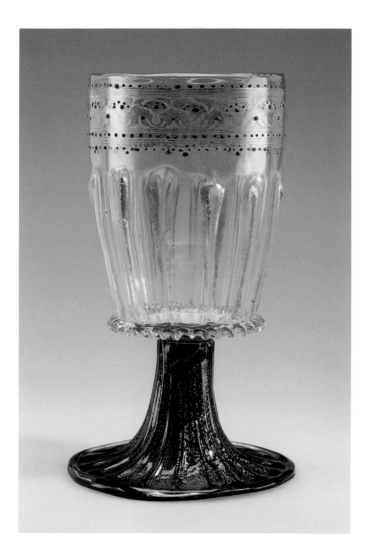

CRISTALLO
Goblet. MOLD-BLOWN
SODA glass with ENAM-
ELED and gilt decora-
tion. H: 18.4 cm
(7¼ in.), Diam (at lip):
9.1 cm (3⁹⁄₁₆ in.). Italy
(Murano), 1475–1500.
JPGM 84.DK.533.

CRISTALLO
The glass beaker holding
the blue columbines — of
essentially the same form
as the BOWL of the Getty
goblet above — is one of
the earliest depictions of
Venetian *cristallo*. Hugo
van der Goes (Flemish,
ca. 1440–1482), *The
Portinari Altarpiece* (detail),
ca. 1475–1476. Tempera
on wood. Florence, Uffizi
Gallery inv. 3192. Photo:
Erich Lessing/Art Resource,
New York.

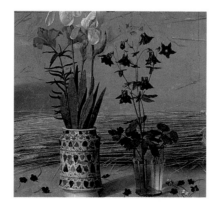

CRIZZLING

A chemical instability in glass caused by an imbalance in the ingredients of the BATCH, particularly an excess of ALKALI or a deficiency of stabilizer (usually LIME). This instability causes the glass to react to moisture in the atmosphere and deteriorate. The process produces a network of fine cracks and surface dampness as the alkaline moisture is drawn to the surface. It is increasingly destructive unless the glass is placed in a stable and controlled environment. Although crizzling can be slowed or perhaps even halted in this way, it cannot be reversed. Glass suffering from crizzling is also known as *weeping*, *sweating*, *sick*, or *diseased*.

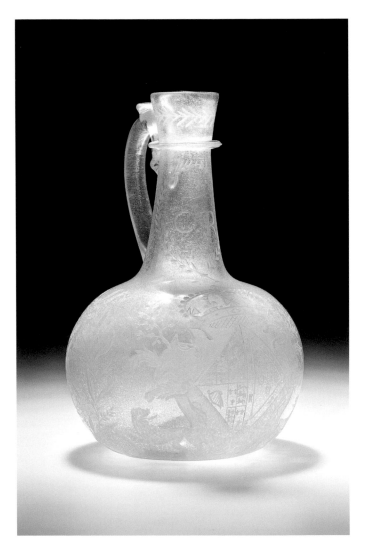

CRIZZLING
Decanter, 1680, by
George Ravenscroft
(English, 1632–1683).
V&A C.165–1993.

CROWN GLASS (see WINDOW)

CRUCIBLE

A cuplike container made of fireclay in which the BATCH of glass ingredients is heated and fused in a FURNACE. Crucibles are of various shapes and sizes depending on the size of the furnace. Also known as a *melting pot*.

Fireclay: a clay capable of being subjected to a high temperature without fusing and used to make the crucibles in which glass batches are melted and fused. Fireclay is rich in SILICA, but it contains only small amounts of LIME, iron, and ALKALI.

Tank: a large receptacle constructed in a furnace for melting the batch. Tanks are used when large quantities of glass are being produced, such as in glass factories.

CRYSTAL

A term used to describe clear, colorless glass of superior quality that has a high REFRACTIVE INDEX and consequently is particularly brilliant. Today the word is often used to describe any fine glass object. See also LEAD GLASS.

CULLET

Fragments of raw or broken glass, often added to the ingredients in a new BATCH to act as a FLUX, reducing the time or temperature required to melt the components. The term is also used to describe scrap glass intended for recycling.

CUP-OVERLAY (see CASING)

CUTTING

Removing glass to shape or decorate an object by grinding it with a rotating wheel made of stone, wood, or metal (frequently copper) attached to a LATHE, and an ABRASIVE suspended in liquid (such as vegetable oil). Although the earliest cut glass vessel was found in the ancient city of Nimrud in Assyria and dates to about 720 B.C., the technique was not used extensively on glass before the Roman period. See also ENGRAVING.

Brilliant cutting: decorating an object with deeply cut elaborate patterns that frequently cover the entire surface and are highly polished. Brilliant cut vessels were especially popular in the United States from about 1880 to 1915.

Cage cup: an ancient Roman vessel decorated by undercutting the design so that it stands free of the body of the glass and is supported by struts

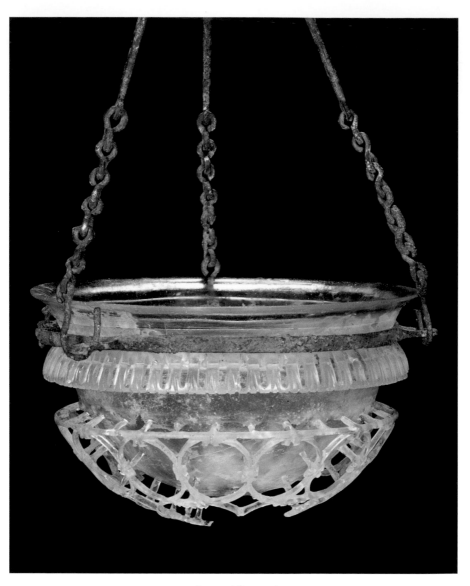

CUTTING (diatretum)
Cage cup. Almost colorless glass; BLOWN or CAST, wheel CUT, and POLISHED. Diam: 12.2 cm
(4¾ in.). Roman, ca. A.D. 300. CMOG 87.1.1, gift of Arthur Rubloff Residuary Trust.

or bridges of glass that are hidden by the decoration. The vessel, therefore, seems to be enclosed in an openwork cage. In most instances, the BLANKS used to carve cage cups were multicolored so that the cage decoration and the interior to which it was attached were of different colorations. Roman cage cups were produced most frequently in the late third and fourth centuries A.D.

Carving: using tools to decorate or shape an object.

Diatretum (Latin, "openwork vessel"): an alternative name for a Roman cage cup. Also known as *vas diatretum* (pl. *vasa diatreta*).

Faceting: cutting and polishing an object with a rotating wheel to give the surface a pattern of planes or facets.

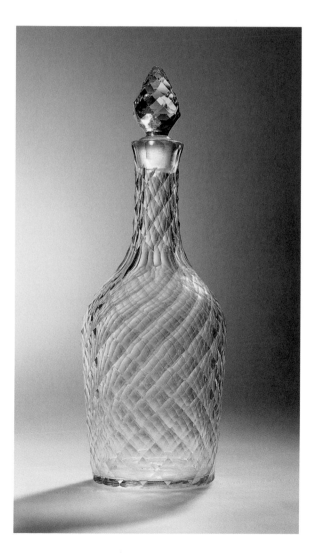

CUTTING (faceting)
Decanter and stopper,
England, ca. 1750.
V&A C.66&A–1928.

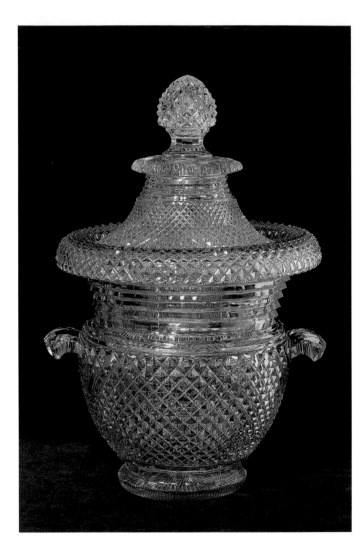

Lathe cutting: using a LATHE to cut a blank in order to polish it, modify the profile, or decorate it. The blank is mounted on the lathe and turned, while a cutting tool fed with an abrasive suspended in a liquid or a stationary wheel is held against the surface.

Openwork: perforated decoration. In addition to cutting, openwork decoration also can be made by applying a network of TRAILS or by CASTING a glass object.

Prismatic cutting: cutting a pattern of long, mitered grooves in straight lines so that the top edges of each groove touch.

Raised diamond cutting: cutting a pattern of raised, pyramid-shaped diamonds with sharp apexes using a mitered wheel. English and Irish glass cutters used this pattern between about 1780 and 1825.

Relief cutting: cutting raised decoration by removing the background with a tool or rotating wheel.

Undercutting: decorating glass in high relief by cutting away part of the glass between the body of an object and its decoration (for example on a cage cup).

CYLINDER GLASS (see WINDOW)

DECOLORIZER

Impurities are inevitably part of the glassmaking process, since they occur naturally in the raw materials and accumulate from handling those materials. The impurity most responsible for discoloring glass is iron, which imparts a greenish-blue tint. To counteract this discoloration, a decolorizer is added to the BATCH. Iron compounds absorb the light penetrating the glass, mainly at the red end of the light spectrum, causing the glass to appear green. In order to make the glass appear more uniformly colorless, various compounds can be added—such as manganese dioxide and cerium oxide—that absorb light on the opposite, or blue, end of the spectrum. Indeed, from the time of the Roman scholar Pliny (A.D. 23–79) until the present, manganese has been the principal decolorizer of glass.

DEVITRIFICATION

The change in glass from its normal noncrystalline state to a crystalline one. This process may occur as a fault, from improper cooling, or ANNEALING (usually too slowly), of the hot glass, or from accidentally heating the glass to an overly high temperature. The term also refers to the crystals formed by this process. When purposely produced in a controlled manner, devitrification can change glass into so-called glass-ceramic, valued for its strength and good thermal-shock resistance.

DIATRETUM (see CUTTING)

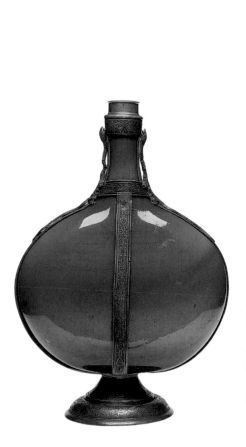

DICHROIC GLASS
(transmitted light)
Flask, *FAÇON DE VENISE*. Free-BLOWN
dichroic glass with
pewter mounts.
H: 33.5 cm (13³⁄₁₆ in.),
W: 22.5 cm (8⅞ in.).
Possibly France,
1550–1600. JPGM
84.DK.519.

DICHROIC GLASS
(reflected light)
Flask, *FAÇON DE VENISE*. Free-BLOWN
dichroic glass with
pewter mounts.
H: 33.5 cm (13³⁄₁₆ in.),
W: 22.5 cm (8⅞ in.).
Possibly France,
1550–1600. JPGM
84.DK.519.

DICHROIC GLASS

A type of glass whose physical properties enable it to appear one color in reflected light and another color when light is transmitted through it. These properties are sometimes due to the presence of minute quantities of colloidal gold, silver, or manganese suspended in the BATCH used to make the object. Dichroic glass was very rare in antiquity; perhaps the best-known example of an ancient dichroic glass is the Lycurgus Cup (now in the British Museum). The glass on the Lycurgus Cup appears khaki green in reflected light, and dark red in transmitted light. See also COLORED GLASS.

DIP MOLD (see MOLD)

DIP OVERLAY (see FLASHING)

DISEASED GLASS (see CRIZZLING)

DRAWN STEM

A type of stem supporting the bowl of a vessel that is made by drawing out or pulling molten glass from the main GATHER. Alternatively, a stem formed from a separate gather can be attached to the bowl (see VESSEL COMPONENTS).

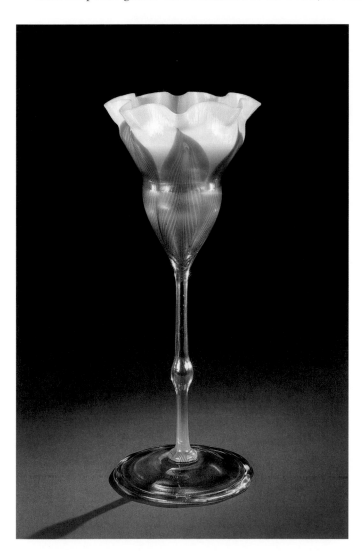

DRAWN STEM
The glassmaker created the stem of this vase by pulling a gob of hot glass away from the BOWL. Flower-form vase. Colorless, transparent green and translucent opalescent white glass; BLOWN, TRAILED, tooled, and IRIDIZED. H: 32.3 cm (12¾ in.). Tiffany Studios, Corona, Long Island, New York, 1900–1905. CMOG 61.4.122.

EGYPTIAN BLUE

Known for its distinctive blue color, Egyptian blue is a partly crystalline compound made from copper calcium tetrasilicate. First created during the Bronze Age, it was made by heating SILICA, LIME, and an ingredient containing copper, together with a FLUX such as sodium (NATRON). Egyptian blue was used to manufacture decorative objects and vessels made in MOLDS. It is often confused with FAÏENCE and is sometimes misidentified with FRIT. Real Egyptian blue is no longer used, but glass of the same color is, so the term now generally refers to the name of a color rather than to a distinct compound.

ENAMEL

A substance composed of finely powdered glass that has been colored with a METALLIC OXIDE, mixed with an oily medium, and then applied to a glass object with a brush. Once the enamel decoration is applied, the glass object is either placed in a low-temperature MUFFLE KILN for FIRING (about 500°–700°C, or 930°–1300°F) or, during the Renaissance, reintroduced to the mouth of the FURNACE at the end of a blowpipe or pontil (see TOOLS). The oily medium burns away during the firing and the enamel fuses to the surface of the glass. Several firings are sometimes required to fuse several different enamel colors to a highly decorated object.

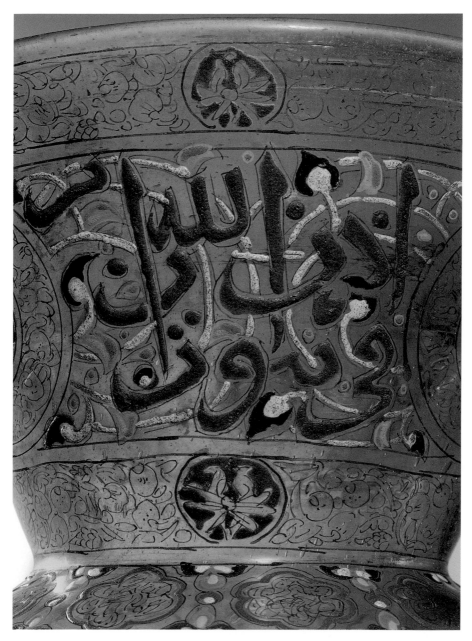

ENAMEL
Mosque lamp (detail), Egypt, 1331–1342. The Arabic script and parts of the medallion ornament
have been painted with thick blue enamel; other parts of the decoration have been highlighted with
red, green, yellow, and white enamel. V&A c.1056–1859.

ENCASING (see CASING)

ENGRAVING

CUTTING into the surface of an ANNEALED glass object either by holding it against a rotating copper wheel fed with an abrasive or by scratching it with a stylus made of a diamond or other hard substance.

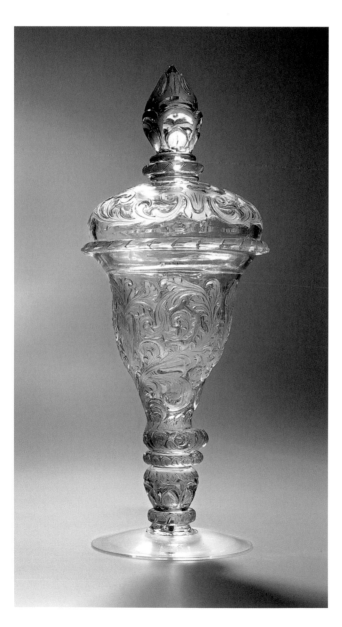

ENGRAVING (*Hochschnitt*) Cup and cover, ca. 1700–1705, engraved by Friedrich Winter (German, fl. 1685–ca. 1710), V&A C.63&A–1954.

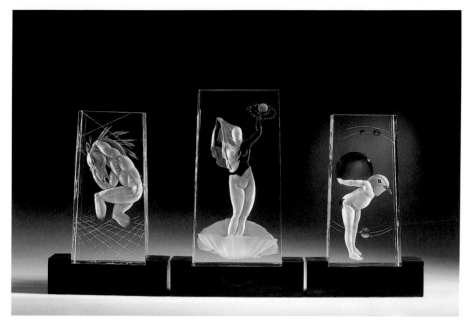

ENGRAVING (*Tiefschnitt*)
Triptych of three engraved blocks representing Past, Present, and Future, 1992, by Alison Kinnaird
(Scottish, born 1949), V&A C.335–1993.

Copper-wheel engraving is used to create ornamentation that lies either above the surface of the glass by removing the background of the pattern, called RELIEF CUTTING or *Hochschnitt*, or beneath the surface of the glass by cutting into the object, called *intaglio* or *Tiefschnitt*. The intaglio areas can also be polished to enhance the relief effect, a technique called *Blankschnitt*, a polished cut that was especially popular in Nuremberg in the seventeenth and eighteenth centuries.

Diamond-point engraving was introduced by the Venetians in the sixteenth century and carried to some of its greatest artistic heights in the Netherlands during the seventeenth century. Craftspersons, especially in the Netherlands and England, also used the technique of STIPPLING to decorate glass. Tapping a sharp pointed tool onto the surface of the glass would leave small marks that, when strategically placed, would define the design.

FACETING (see CUTTING)

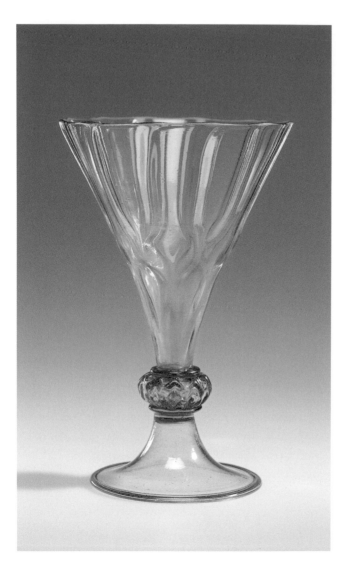

Façon de Venise (French, "style of Venice")

Glass made in imitation of Venetian products at centers other than Venice itself. Given the prestige, desirability, and high importation costs of Venetian glass, centers throughout Europe — especially in France, England, Germany, Bohemia, the Netherlands, Spain, and England — produced their own versions of *façon de Venise* glass in the sixteenth and seventeenth centuries. This non-Venetian glass can appear so similar as to be difficult to distinguish from the Venetian examples.

FAÏENCE

A ceramic-like material made from powdered quartz (or a similar silicate material), LIME, and NATRON, which are combined with water to make a clay-like paste. Faïence is used primarily to construct molded figures, pendants, and vessels, but some objects were made by throwing them on a wheel. Once constructed, the faïence is FIRED to harden the material. Some faïence objects are covered with a vitreous glaze; on others, the quality of the quartz itself creates a glazed effect during firing.

FILIGREE GLASS (Italian, *vetro a filigrana*)

Any blown glass made with colorless, white, and sometimes colored canes. The filigree style originated at Murano in the sixteenth century and spread rapidly to other parts of Europe where FAÇON DE VENISE glass was produced. Manufacture at Murano continued until the eighteenth century and

FILIGREE GLASS
(*vetro a fili*)
Beaker, FAÇON DE
VENISE. Free-BLOWN
glass with embedded
white CANES (*vetro a
fili*). H: 14 cm (5½ in.),
Diam (at lip): 10.2 cm
(4 in.). Probably the
Netherlands,
1550–1625. JPGM
84.DK.658.

was revived in the twentieth century. There are three main types of filigree glass: *vetro a fili* ("glass with threads"); *vetro a reticello*, or *redexello* ("glass with a small net pattern"); and *vetro a retorti*, or *retortoli* ("glass with twists"). *Vetro a fili* displays CANES that form a pattern of parallel lines. *Vetro a reticello* is made by arranging the canes in a crisscross pattern to form a web or lattice. Sometimes an air trap is produced between each of the net interstices, enhancing the glittering, brilliant quality of the glass (see also BUBBLE). *Vetro a retorti* contains canes that have been twisted to form spiral patterns.

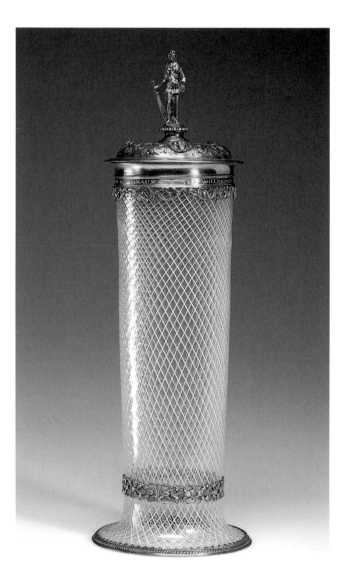

FILIGREE GLASS
(*vetro a reticello*) Covered filigrana beaker, *FAÇON DE VENISE*. Free-BLOWN glass with embedded white CANES and air BUBBLES (*vetro a reticello*) and silver-gilt mounts. H (with lid): 31.3 cm (12¼ in.); Diam (at base): 10.2 cm (4 in.). Germany or Italy (Murano), 1550–1600; mounts, Germany (Augsburg), 1615–1625. JPGM 84.DK.513.1–2.

Most often, filigree glass is made from only clear and white glass canes. The white canes are made of *LATTIMO*, or milk glass (*latte* is Italian for "milk"), whose opaque white appearance is produced by the addition of tin oxide to the BATCH. Indeed, the old term for this glass was *latticinio* or *latticino*. The combination of white and clear canes heightens the lacy appearance of the glass and may actually relate to the concurrent and important Venetian production of lace. In the nineteenth and twentieth centuries, *VETRO ZANFIRICO* and *MEZZA FILIGRANA* were introduced. Similar filigree canes were made in antiquity, but the vessels in which they were used were cast rather than BLOWN (see *ribbon glass* under MOSAIC GLASS).

FIRECLAY (see CRUCIBLE)

Fire polishing

The process of reintroducing a vessel into the GLORY HOLE to melt the surface and eliminate surface irregularities. Fire polish is the smooth, shiny finish imparted to a vessel resulting from repeated heating in the glory hole.

Firing

Heating a glass FURNACE to a predetermined temperature and maintaining that temperature for as long as required. Three different processes of glass-making occur in the heated glass furnace: Heating the BATCH contained in a CRUCIBLE or tank in order to fuse it into glass, which requires a temperature between 1300° and 1500°C (about 2400°–2700°F); reheating glassware while it is in the process of being manipulated (see REHEATING); or reheating glass-ware in a MUFFLE KILN to fuse ENAMEL or GILDING, which requires a temper-ature of only 500°–700°C (about 930°–1300°F).

The term also refers to the process of using heat to convert clay to a ce-ramic material. FIRECLAY pots with walls about two inches thick normally have to be fired in a controlled manner over several days before they can be transferred to the glass-melting furnace. See also POT ARCHING.

Flamework

To form objects from rods and tubes of glass by heating them in a flame (referred to as *at-the-flame*). Initially, the source of the flame was an oil or paraffin lamp used with foot-powered bellows to get the flame hot enough to soften the glass for manipulation (hence the name *lampwork*); since the nine-teenth century, gas-fueled torches are used.

Flashing

The technique of FUSING molten glass of one color onto the outer surface of glass of another color by dipping one into a BATCH of the other. This is also known as *outside casing* and *dip overlay*. See also CASING.

Flint glass

A term used to describe glass made in England in the seventeenth century in which powdered flint (impure quartz) was used in lieu of sand as the source of SILICA. The process was patented in 1674 by the English glassmaker George Ravenscroft. The term is often mistakenly used to identify English and American LEAD GLASS.

Float glass (see WINDOW)

FLAMEWORK (LAMPWORK)
Pair of tall vases, flame-worked glass. A hot flame from a torch was used to reheat the glass while it was
manipulated with TOOLS to create these two vase shapes. Germany (probably Thuringia), ca. 1900.
V&A C.34–1916 and C.38–1916.

FLUX

An ALKALINE substance that lowers the melting point of materials in a mixture, thereby facilitating their FUSION. For example, a flux is added to the BATCH in order to melt the SILICA, which normally requires very high and, therefore, hard-to-reach temperatures to fuse. Fluxes are also added to ENAMELS in order to lower their fusion point to below the softening point of the glass body to which they are applied, so that they will affix to the glass before the glass gets so hot that it loses its shape. POTASH and SODA are fluxes. See also CULLET.

FOLDED RIM

A double thickness of glass that occurs at the edge of a vessel. It is formed by folding a narrow band back onto itself, sometimes trapping a ring of air. A folded rim is often found on the foot or bowl of a vessel (see VESSEL COMPONENTS). The fold may be toward the outer surface (*outside fold*) or toward the inner surface (*inside fold*). In either case it is both decorative and functional, serving as a strengthening device.

FOLLOWERS (see MOLDING)

FONDI or **FONDO D'ORO** (see GOLD GLASS)

FOOT (see VESSEL COMPONENTS)

FOOTBOARDS (see TOOLS)

FORMER MOLD (see MOLD)

FOUNDING

The beginning stage of melting the BATCH to make workable glass. In antiquity, the batch could begin melting at a temperature of about 1300°C (about 2400°F). Due to higher degrees of refinement in the materials used to make modern glass, many must be heated to a temperature of about 1400°C (about 2550°F) or higher. Founding is followed by a maturing period, during which the molten glass cools to a working temperature of about 1100°C (about 2000°F). In antiquity, the maturing period might take several days before workable glass was obtained.

FREE BLOWING (see BLOWING)

FRIT

An ingredient of the BATCH that helps control a soluble or volatile substance. The frit—for example, the SILICA and ALKALI—must first be heated but not melted to drive off moisture or gas that might result from melting, thereby contaminating the batch. After cooling, the frit is ground into a powder. The process of making a frit is called *fritting*. In modern glassmaking this process is not necessary due to the use of relatively pure glass ingredients.

FRITTING (see SINTERING)

FROSTING

A term used to describe two different conditions found on the surface of glass: a matte finish produced by deliberately exposing the object to fumes of hydrofluoric acid in order to create a decorative effect (see ACID ETCHING), or a network of small surface cracks caused by WEATHERING.

Matte finish: a decorative, deliberately dull finish made by grinding, SANDBLASTING, or exposing the surface of glass to fumes of hydrofluoric acid while it is being manipulated.

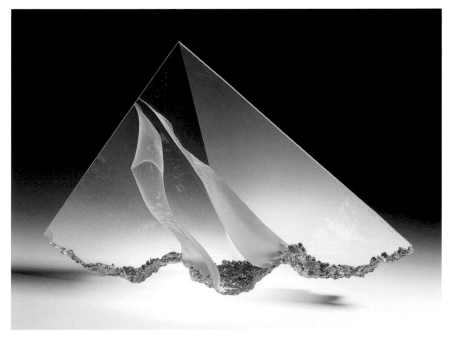

FROSTING
Pyramid sculpture. Two triangular areas of this sculpture were first FROSTED to create a matte surface and then ENCASED in clear glass. Colin Reid (British, born 1953), 1999. V&A C.10–2000.

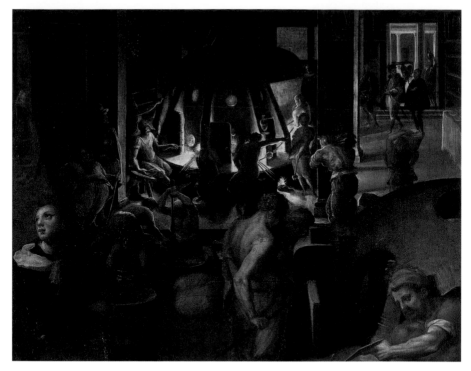

FURNACE and GLORY HOLE

The glassmaker wearing a protective visor to the left of the furnace sits on a CHAIR, holding jacks in his right hand and a PONTIL in his left (see TOOLS). He has inserted either a blowpipe or pontil, on which largely unseen hot glass is attached, into the glory hole. In front of the furnace, another glassmaker attaches a gob of hot glass at the end of a pontil onto a PARISON, which he has inflated with the blowpipe. To the right of the furnace, an elegantly posed glassblower inflates a gob of hot glass. Other workmen are engaged in various tasks such as bringing in wood to fuel the furnace and GRINDING ingredients. Giovanni Maria Butteri (Italian, 1540–circa 1606), *The Medici Glass Workshop* (detail), 1570. Fresco. Florence, Palazzo Vecchio, Studiolo of Francesco I. Photo: Scala, Milan.

FURNACE

An enclosed structure used for the production and application of heat. In glassmaking, furnaces are used for melting the BATCH, maintaining pots of glass in a molten state, and REHEATING partly formed objects at the GLORY HOLE.

FUSING

Using heat to bond two or more pieces of glass together in a KILN or FURNACE (see also MOSAIC GLASS), or heating enameled vessels in a MUFFLE KILN until the ENAMEL bonds with the surface of the object. See also *PÂTE DE VERRE*.

GADGET (see TOOLS)

GAFFER

The master craftsperson in charge of a team—also called a CHAIR or a *shop*—of hot-glass workers. A glass article fashioned in a glasshouse is not so much the product of an individual as that of a team, and the gaffer directs this action. The term is a corruption of the word *grandfather*.

GARAGE (see ANNEALING)

GATHER

A gob or mass of molten glass collected on the end of a tool such as a blow-pipe, pontil, or gathering iron (see TOOLS). The term also refers to the action of collecting the glass by rotating the iron while dipping its tip ("*nose*") into the molten glass.

GATHERING IRON (see TOOLS)

GILDING

Decorating a glass object by applying gold leaf, gold paint, or gold dust to its surface, which may then be fused to the glass by FIRING. Gilding may be applied to an object with SIZE, amalgamated with mercury, or—as gold leaf—be picked up by the hot glass directly from the marver before the object is BLOWN (see TOOLS).

GILDING
The mythological figures on this pitcher were gilded and then enhanced with gray and red paint, as were the decorative bands that encircle the neck. The figural decoration was achieved by both gilding and COLD PAINTING. *The Daphne ewer*. Translucent to opaque white glass; BLOWN, cold painted, and gilded. H: 22.2 cm (8¾ in.). Roman, late second–early third century A.D. CMOG 55.1.86.

GLASS

A hard, brittle, and usually transparent or translucent material that is synthetically made by combining and fusing some form of SILICA (sand, quartz, or flint) with an ALKALI FLUX (SODA or POTASH) to lower the melting point of the silica and a stabilizing agent such as LIME or lead oxide to make the resulting glass insoluble. Technically, glass is neither a solid nor a liquid. It is referred to as an *amorphous solid* (lacking the crystalline form typical of solids) or a *rigid liquid* (since it retains many of the qualities of a liquid, such as flow). The rare examples of glass produced in nature include obsidian, pumice, and fulgurites.

Glass was first intentionally produced in Mesopotamia around 2500 B.C. to create small objects such as beads. Later techniques, including core forming (see CORE) and glassblowing (see BLOWING) allowed glassmakers to begin to exploit the usefulness of the material to form vessels. The practical and decorative properties of glass continue to develop as technical advances are made.

GLASS-CERAMIC (see DEVITRIFICATION)

GLORY HOLE

Either an opening in the side of the glass FURNACE or a smaller, separate furnace used for REHEATING the hot glass object being produced or decorated. Reheating softens the glass, making possible changes or additions to the object. Inserting an object into the glory hole serves to FIRE POLISH the piece, thereby melting and eliminating small surface imperfections. From *glaury*, meaning "muddy," the term originally referred to a small receptacle for the untidy heaping of material—such as a prisoner's cell or a ship steward's quarters—and for the cavernous opening into a mine or quarry.

GOLD GLASS

A term referring to several varieties of glass objects decorated with designs CUT, ENGRAVED, or occasionally painted in gold leaf, which is sandwiched between two FUSED layers of glass. Hellenistic gold glass was made by sandwiching gold leaf decoration between two closely fitting cast, ground, and polished vessels that were then fused. It is sometimes called *sandwich glass*. Many late Roman gold glasses were made by applying the gold leaf to the surface of an object, reheating it, and inflating a PARISON against the decorated surface to protect it from wear. These pieces are sometimes known by the Italian term *fondi d'oro*. The edges of many of these pieces are GROZED, and it is

possible that they were originally part of a vessel base, or perhaps they were intended to be finished in this manner. Many are decorated with portraits or with Christian images and were found embedded into the walls of catacombs in Rome.

Zwischengoldglas (German, "gold between glass"): a type of glass decoration used in Bohemia and Austria in the nineteenth century. A design in gold or silver leaf is sandwiched between two vessels that fit closely together. Unlike Hellenistic or Roman gold glass, *Zwischengoldglas* is held together with cement.

GRINDING (see CUTTING)

GROZING

Shaping a glass object by snapping or breaking away the edge with a grozing iron or pliers (see TOOLS).

HAND PRESS (see TOOLS)

HINTERGLASMALEREI (see REVERSE PAINTING)

HOT FORMING

A term referring to the manipulation of glass while it is hot. It is synonymous with *hot working*.

HOT WORKING (see HOT FORMING)

HYDROFLUORIC ACID (see ACID ETCHING)

ICE GLASS

A type of glass developed around the mid-sixteenth century in Venice—and then popular throughout Europe, especially in Spain and the Netherlands—with a distinctive surface that calls to mind shattered ice. Two techniques were used to produce this effect. The first involved plunging a PARISON of glass into cold water to create a fine network of cracks in the glass without causing it to shatter. The parison was then carefully worked to form the desired object while maintaining the crackled appearance. With the second method, a BUBBLE of hot glass was rolled, thereby picking up glass shards that had been placed on a marver (see TOOLS and see also PICK-UP DECORATION). The bubble was then worked to incorporate the glass bits into the wall of the piece, preserving the crackle pattern.

ICE GLASS
The ice-glass effect on this piece was made by rolling the hot glass over small bits of glass that then stuck to the surface. Situla (bucket), *FAÇON DE VENISE*. Free-BLOWN grayish-brown ice glass. H: 11.2 cm (4⅜ in.), Diam: 19.8 cm (6⅝ in.). Italy (Murano) or the Netherlands, 1650–1700. JPGM 84.DK.657.

INCALMO

The process of joining with heat two or more distinct pieces of blown glass of
different color or decoration. The blown bubbles are cut and fused along their
rims, and the resulting object is shaped and finished.

INCLUSIONS

Any particles, including solid bits of metal or bubbles of air, that were either
accidentally incorporated as foreign matter in the glass or deliberately added
for decorative effect.

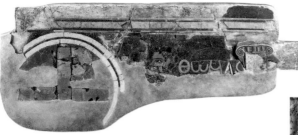

INLAY

Fragment of panel with Thomas (full overall view and detail). Opaque and translucent glass of various colors and gold sandwich glass, all in a resinous matrix backed with rectangular pieces of earthenware.

L: 79 cm (31⅛ in.). Reputedly found in the Fayum, Egypt, probably second half of fourth century A.D. CMOG 86.1.1.

INLAY

An object embedded in the surface of a larger object. In antiquity, glass elements were inlaid into buildings to accentuate architectural features or as decorative panels, a practice that continues today. Glass elements were also incorporated into luxurious pieces of furniture. See also MOSAIC.

INSIDE CASING (see CASING)

INSIDE FOLD (see FOLDED RIM)

INTARSIA

A decorative technique developed in the early twentieth century whereby a design of colored glass was applied to a PARISON of a different color and FLASHED with a second parison of the same color as the first. The term is derived from the Italian *intarsia* for "marquetry" although the technique differs from that for marquetry decoration. See also PICK-UP DECORATION.

INTERCALAIRE (French, "inserted")

Applying two layers of decoration to a glass object. The first layer of decoration is covered with a skin of glass that serves as the surface for the second layer of decoration. The technique is most frequently associated with Art Nouveau, particularly the work of the French glass- and furniture maker Émile Gallé (1846–1904).

IRIDESCENCE

A rainbow-like visual effect that changes according to the angle from which an object is viewed or the angle of the source of light. Ancient glass often appears iridescent; this is not an effect sought by ancient glassmakers but, rather, the result of WEATHERING. On certain nineteenth- and twentieth-century glasses, iridescence is an effect deliberately achieved by introducing metallic substances into the BATCH or by spraying the surface with stannous chloride or lead chloride while the vessel is being constructed and reheating it in a REDUCING ATMOSPHERE. Iridescence was especially popular with Art Nouveau glass artists and is most often associated with the work of the American painter and stained-glass artist Louis Comfort Tiffany (1848–1933).

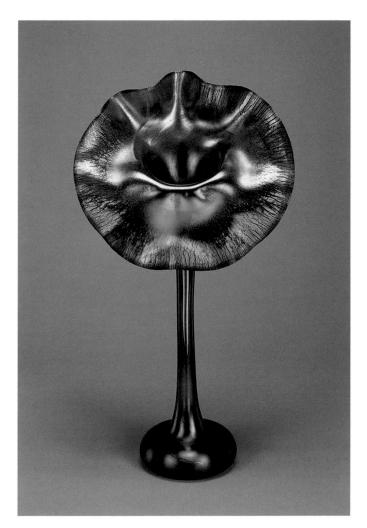

IRIDESCENCE
Jack-in-the-pulpit vase. Transparent dark blue glass; BLOWN, iridized. H: 47.6 cm (18¾ in.). Tiffany Studios, Corona, Long Island, New York, ca. 1912. CMOG 62.4.61.

Jacks (see TOOLS)

Kick

The deep impression formed in the bottom of a glass vessel by pushing a tool into the base of the piece while it is still on the blowpipe (see TOOLS). The resulting conical indentation serves to strengthen the base, reduce the volume of the vessel, and collect sediment from the liquid inside. The kick also helps the vessel stand firmly upright since the surface that comes in contact with a table or shelf is reduced to a ring formed by the base's circumference.

KICK
Bottle. Transparent light green glass; MOLD BLOWN. H: 28.1 cm (11⅛ in.). Roman, fourth–mid-sixth century A.D. CMOG 54.1.97.

Kiln

An oven used to process a substance by burning, drying, or heating. In glassmaking, kilns can be used for a variety of purposes, including forming an object by slumping (see MOLDING), decorating an object by fusing ENAMEL to its surface, and ANNEALING a completed object. See also FURNACE.

Kiln forming (see MOLDING)

Knop (see VESSEL COMPONENTS)

Lactesin (see *LATTIMO*)

Ladle (see TOOLS)

Lampwork (see FLAMEWORK)

Latesin (see *LATTIMO*)

LATHE

A tool used to polish, cut, or modify the profile of a BLANK. The blank is mounted on a rotating surface while a tool holds abrasives against the glass.

Bow lathe: An early lathe powered with a bow. The bowstring is looped around the spindle of a lathe and, when the bow is drawn back and forth, the spindle rotates and turns the wheel used to cut or carve glass.

LATHE CUTTING (see CUTTING)

LATTICINIO, LATTICINO (see FILIGREE GLASS)

LATTIMO (OR *MILCHGLAS*)

From the Italian word for "milk" (*latte*; *Milch* in German). Opaque white glass made by adding bone ash, tin oxide, zinc, or other materials to the BATCH. This glass was used to create whole vessels in emulation of Chinese

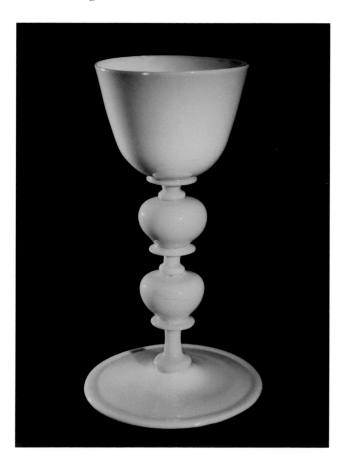

LATTIMO
Goblet. Opaque white glass, BLOWN and assembled. H: 15.9 cm (6¼ in.). Italy, possibly Altare, late seventeenth century. CMOG 65.3.43.

porcelain, as well as to form CANES that were embedded into clear glass to create *filigrana* patterns. A transparent white glass is called *latesin* or *lactesin*.

LEAD GLASS

Glass that contains a high percentage of lead oxide (at least 20 percent of the BATCH). In modern times, glass of this type was first produced in the Netherlands. The technology used to produce lead glass was made economically viable in England by George Ravenscroft (1618–1681) about 1676. It is relatively soft and easier to cut, and its high REFRACTIVE INDEX gives it a brilliance that can be exploited by decorating the surface with polished wheel-cut facets. See also CRYSTAL and FLINT GLASS.

LEHR, LEER (see ANNEALING)

LIME

Calcined limestone, which gives stability to the BATCH when added in small quantities. In antiquity, lime was introduced as an accidental if fortuitous impurity in the raw materials. It was not until the seventeenth century that its beneficial effects became known.

LIPPER (see TOOLS)

LOST-WAX CASTING (see CASTING)

LUSTER

A shiny metallic effect created by painting the surface of an object with METALLIC OXIDES that have been dissolved in acid and mixed with an oily medium. FIRING in oxygen-starved conditions (a REDUCING ATMOSPHERE) at a temperature of about 600°C (about 1100°F) causes the metal to be deposited on the surface of the vessel in a thin film that, after cleaning, has a distinctive shiny surface. The term also refers to a lighting device decorated with pendant prismatic drops.

LUSTER
Blue Aurene vase. Transparent, deep blue glass, IRIDIZED, APPLIED, and tooled. Designed by
Frederick Carder (American, 1863–1963). H: 29.5 cm (11⅝ in.). Steuben Division, Corning
Glassworks, New York. CMOG 51.4.743, gift of Frederick Carder.

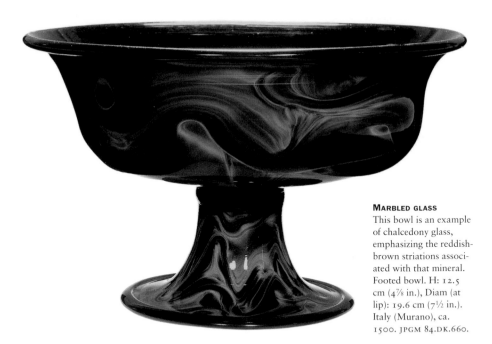

MARBLED GLASS
This bowl is an example
of chalcedony glass,
emphasizing the reddish-
brown striations associ-
ated with that mineral.
Footed bowl. H: 12.5
cm (4⅞ in.), Diam (at
lip): 19.6 cm (7½ in.).
Italy (Murano), ca.
1500. JPGM 84.DK.660.

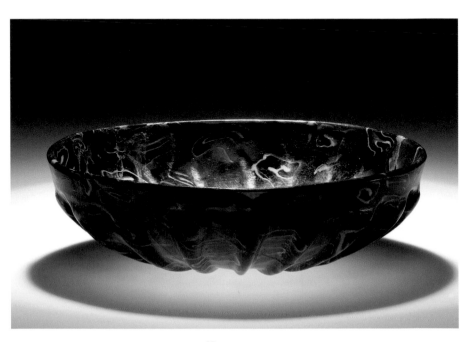

MARBLED GLASS
Ribbed bowl. H: 4.9 cm (1⅞ in.). Roman, first century B.C. JPGM 2004.25.

MARBLED GLASS

Glass decorated with streaks of two or more colors, resembling marble or semiprecious stone. The technique used to produce this glass involves stirring colored glass in the pot only briefly, so that the colors do not blend. Glass produced from this BATCH maintains the swirling effects of colored stone.

Calcedonio (Italian, "chalcedony glass"): An important Venetian specialty from the mid-fifteenth to the seventeenth century, comprising glass made in imitation of various stones such as chalcedony and agate, as well as marble. Interest in creating this glass resulted from the general Renaissance fascination with natural phenomena and the presence of classical and Byzantine stone vessels in contemporary collections.

MARQUETRY (see PICK-UP DECORATION)

MARVER (see TOOLS)

MATTE FINISH (see FROSTING)

MELT

The molten mixture of raw materials that make glass. The term BATCH is often used interchangeably with *melt*.

MELTING POT (see CRUCIBLE)

MERESE (see VESSEL COMPONENTS)

METAL

A term sometimes used as a synonym for molten glass. Glass, however, is not properly a metal. The misleading use of this term may derive from the fact that chemical metallic substances such as potassium and sodium are components of glass.

METALLIC OXIDE

A compound in which a metal is chemically combined with oxygen. In glassmaking, certain metallic oxides—such as the oxides of copper, antimony, iron, manganese, tin, cobalt, and silver—are used as coloring agents for the glass body and ENAMEL pigments or to create a LUSTERED effect on the glass surface. The resultant color depends primarily on the oxide used but can also be affected by the composition of the glass itself and by the presence or absence of oxygen in the FURNACE.

Mezza filigrana (Italian for half filigree)

A pattern of fine spiral canes or threads. This differs from *vetro a torti* (*a retortoli*) in that it does not include the twisted pattern.

Mezza-forma (see MOLDING)

Mezza-stampatura (see MOLDING)

MILLED THREADING

Decoration consisting of a TRAIL (thread) of hot glass that has been notched by the use of a toothed wheel called a *roulette* or by repeated indentation with the edge of a jack (see TOOLS). Not to be confused with PINCHING.

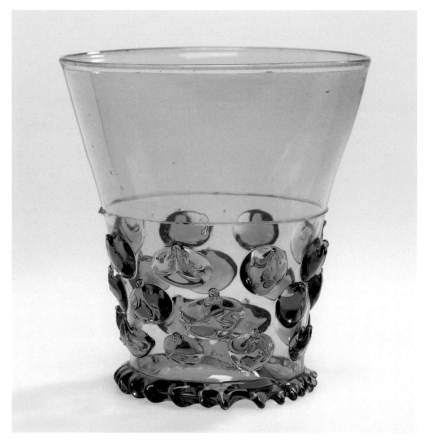

MILLED THREADING
The serrated ring around the base of this glass is an example of milled threading. PRUNTED beaker.
H: 13.3 cm (5⁵/₁₆ in.), Diam (at lip): 12.9 cm (5¹/₁₆ in.). Southern Germany (Lower Rhineland), or possibly the Netherlands, 1500–1550. JPGM 84.DK.527.

MILLEFIORI (from the Italian *mille fiori*, "thousand flowers")

Glass made or decorated by embedding cross-sections of multicolored, concentrically patterned CANES, first appearing in Renaissance Venetian and FAÇON DE VENISE glass. The term has been applied in the past to Roman MOSAIC GLASS.

MOIL (see OVERBLOW and CRACKING OFF)

The surplus glass left from the glassblowing or molding process. It is usually cracked off and returned to the BATCH as CULLET.

MOLD

A receptacle used for shaping and/or decorating molten glass. Some molds impart a pattern to the PARISON when it is inflated inside the mold. After the parison is withdrawn from the mold, it can be further inflated and tooled to the desired shape and size. Other molds are used to give a glass object its final form, with or without decoration.

Dip mold: a cylindrical, one-piece mold that is open at the top so that the GATHER can be dipped into it, inflated, and then removed.

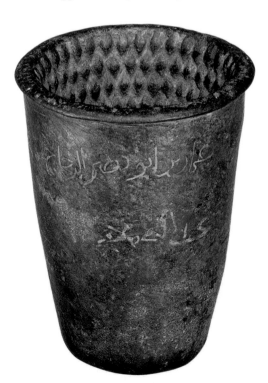

MOLD
Islamic dip mold.
Brass; CAST, incised inscription. H: 11.4 cm
(4½ in.). Probably
Western Asia,
eleventh–thirteenth
century. CMOG 86.7.15.

Former mold: a mold with the same shape as the desired object, usually a vessel. A flat blank is shaped into a vessel by sagging it over or into a former mold (see MOLDING).

Optic mold: an open mold with a patterned interior in which a parison of glass is inserted and then further inflated to decorate the surface.

Piece mold: a mold made of two or more parts.

Pillar mold(ed): a term used by nineteenth-century English glassmakers to describe vessels made by them with MOLD-BLOWN vertical ribs on their exterior, but no corresponding indentations on the interior. This design was created by partly inflating the gather, allowing it to cool sufficiently to become somewhat rigid, and then gathering an outer layer of glass around it. The parison was then further inflated in a ribbed dip mold, which shaped the soft outer layer without affecting the inner layer. The term is frequently, but incorrectly, applied to ancient Roman bowls with exterior ribbing, which were made in a different manner.

MOLD BLOWING

Inflating a PARISON in a MOLD. When inflated, the glass is forced against the inner surface of the mold and takes the shape of both the mold and any decoration that it bears. See also BLOWING.

Broken-swirl ribbing: mold-blown decoration that has two sets of ribs. The decoration is made by blowing the GATHER or parison in a vertically ribbed dip mold, extracting and twisting it to produce a swirled effect (see *swirled ribbing* below), and then redipping it in the same or another dip mold and inflating it again to superimpose a second set of ribs over the first.

Swirled ribbing: a pattern of spiraling vertical ribs made by inflating the parison in a dip mold with vertical ribs, withdrawing it, and twisting it before continuing the process of inflation. The ribbed pattern is also described as *wrythen.*

MOLD BLOWING
Spirally ribbed mold blowing; the stem is further enhanced with TRAIL decoration.
Goblet, England (London), 1869. V&A C.105–1870.

MOLD BLOWING
For this vase, the glassmaker inflated the hot glass in a MOLD embossed with a pineapple-like pattern. *Umbo* vase, FAÇON DE VENISE. H: 46.2 cm (8⁵⁄₁₆ in.), max. Diam: 13.0 cm (5⅛ in.). Possibly from the *Glashütte* (German, "glassworks") of Wolfgang Vitl (active 1534–1540), ca. 1534–1536. JPGM 84.DK.546.

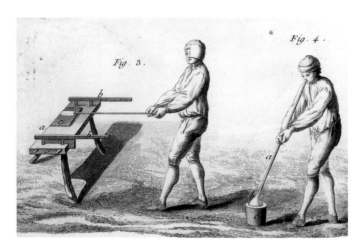

MOLD BLOWING
The glassblower first rolls the gob of hot glass on a MARVER (fig. 3, c) to make an evenly centered cylinder; he then inflates the gob into a dip mold (fig. 4, c) (see MOLD) using a blowpipe (fig. 4, a) (see TOOLS). From Denis Diderot and Jean Le Rond d'Alembert, *Recueil des planches, sur les sciences et les arts liberaux et les arts méchaniques, avec leur explicacion* (Paris, 1772), vol. 10, pl. 19, figs. 3–4. Los Angeles, Research Library, GRI no. 84-B31322. Photo: GRI.

MOLDING

Using a MOLD to shape or decorate the surface of an object.

Kiln forming: fusing or shaping powdered or crushed glass in or over a mold by heating it in a KILN.

Lost-wax casting (see CASTING)

Mezza-forma: (Italian, "half mold") making vertical ribs on the lower part of a blown object by inflating the bottom half of a PARISON into a dip mold. Also known as *mezza-stampatura*.

Pattern molding: inflating glass into a mold with a concave pattern. Pattern molds are not used to make the final shape of an object.

Pillar molding (see MOLD)

Pressed-glass technique: placing a blob of glass in a metal mold and then pressing it with a metal plunger, or *follower,* to form the interior shape. The resultant piece, called *mold pressed*, has an interior form independent of the exterior, in contrast to mold-blown glass, whose interior corresponds to the outer form. The process of pressing glass was first mechanized in the United States between 1820 and 1830 and is used in industrial glassmaking.

Sagging: reheating a glass object so that the glass gradually flows under the influence of gravity into a former mold, taking on the shape of the mold.

Sand molding: a technique in which molten glass is poured or ladled into a mold of compacted sand. A roughly textured granular surface results where the glass comes into contact with the sand.

Slumping (see sagging, above)

MOLD MARK

This cup was made in a three-piece
MOLD. Some of the molten glass
seeped out in the seam of the mold
(above), which was not completely
tight. The detail view shows how
Roman glassmakers could incor-
porate a mold mark into the de-
sign in order to conceal the mark.
Roman, first century A.D. H: 7.8
cm (3 1/16 in.). JPGM 2004.35.

MOLD MARK (SEAM MARK)

A slight relief ridge on a glass object that indicates that it has been made by
MOLDING. The mold marks appear where gaps in the joins between the dif-
ferent parts of the mold have permitted molten glass to seep through during
formation. Ancient Roman glassmakers often tried to incorporate their mold
marks into their decorative patterns in order better to disguise them.

MOLD PRESSED (see MOLDING)

MOSAIC

A surface decorated with many small, adjoining pieces of multicolored mate-
rials such as stone, ceramic, or glass. See also INLAY.

Tessera (Greek, "four"): a small piece of glass or other suitable material,
usually having four sides, used to make mosaics. Pl. *tesserae*.

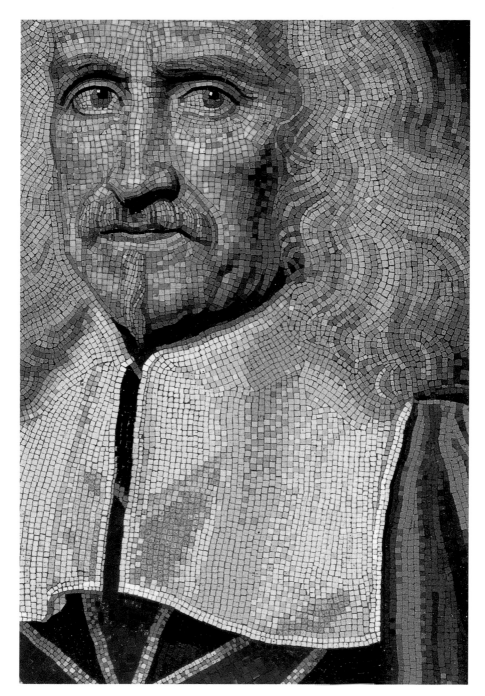

MOSAIC
The small tiles, or tesserae, that compose the image of this mosaic are cut from pieces of COLORED GLASS.
Attributed to Giovanni Battista Calandra (Italian, 1586–1644), *Portrait of Camillo Rospigliosi* (detail),
ca. 1630–1640. JPGM 87.SE.132.

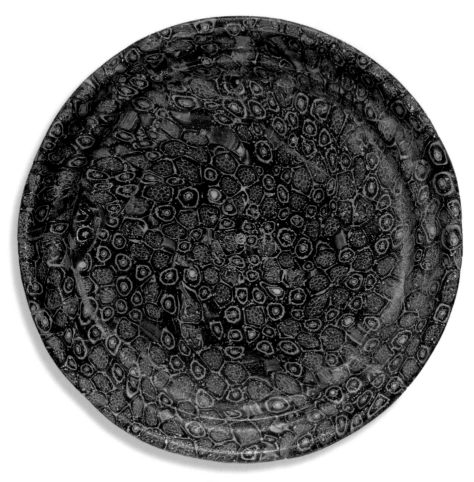

MOSAIC GLASS
Dish. Roman, end of first century B.C.–early first century A.D. Diam: 16 cm (6¼ in.).
JPGM 85.AF.85.

MOSAIC GLASS

Objects made from preformed monochrome or polychrome elements (often cut from CANES) that are placed in a mold and heated until they FUSE. Hellenistic and Roman glassmakers first fused their elements into a disk before sagging them over a former mold of the desired shape (see MOLDING). See also MILLEFIORI.

Ribbon glass: a type of late Hellenistic and first-century A.D. Roman mosaic glass made from ribbonlike canes arranged in parallel rows or in geometric patterns; or, a type of *vetro a reticello* made in Venice and at FAÇON DE VENISE production sites. See also FILIGREE GLASS.

MUFF GLASS (see WINDOW)

MUFFLE KILN

A KILN for a FIRECLAY box, or muffle, in which glass (or ceramic) objects are enclosed to protect them from flames and smoke during low-temperature FIRING, especially when firing ENAMELS and GILDING at temperatures of about 500° to 700°C (about 930°–1300°F).

NATRON

A mineral composed of different sodium salts (sodium sesquicarbonate) commonly used by Roman glassmakers as the ALKALI constituent (FLUX) in the BATCH. Natron was originally obtained from the Wadi an-Natrun, about sixty-two miles southwest of Alexandria, Egypt, in deposits formed by the evaporation of river water.

NATURAL GLASS (see COLORED GLASS)

NIPT DIAMOND WAIES

A diamond pattern created by pinching together adjacent vertical ribs that have been created by TRAILING or MOLDING.

NOSE (see BLOWING)

OPENWORK (see CUTTING)

OPTIC MOLD (see MOLD)

OUTSIDE CASING (see FLASHING)

OUTSIDE FOLD (see FOLDED RIM)

OVERBLOW

The portion of the PARISON that remains outside the MOLD after inflation. The overblow, or MOIL, is usually removed by CRACKING OFF.

OVERBLOW
The body of this flask was inflated into a cylindrical MOLD; the glass, not confined by the mold, bulged over the top to create an overblow, or MOIL (arrow). Vase with mythological figures. H: 19.8 cm (7¾ in.). Roman, late first–early second century A.D. CMOG 79.1.29, gift of Richard C. Reedy.

OVERLAY
Glass, overlaid clear,
opaque white, and
ruby; CUT decoration.
Footed BOWL, England
(probably Stourbridge),
ca. 1850–1855.
V&A C.295–1967.

OVERLAY

A layer of glass that covers a layer of a different color. The overlay is usually applied by CASING, FLASHING, or CASTING (for flat BLANKS).

OXIDIZING ATMOSPHERE

An atmosphere in a KILN or FURNACE that has an excess of oxygen. Increasing the amount of oxygen in the furnace will help to stabilize those glass colors dependent on it, such as purple and amber.

Chemical oxidation is the creation of an oxidizing condition in the MELT by adding a special agent such as potassium nitrate (saltpeter) to the BATCH.

PALLET (see TOOLS)

PAPER (see TOOLS)

PARISON

The bubble created by a GATHER on the end of a blowpipe that is already partly inflated (see TOOLS). The term derives from the French *paraison*, meaning the initial appearance of a thing (from the verb *paraître*, "to appear").

PARROT-NOSED SHEARS (see TOOLS)

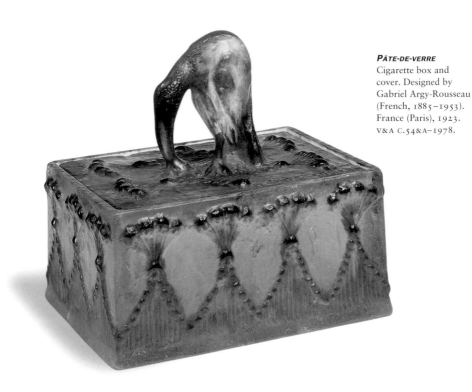

PÂTE-DE-VERRE (French, "glass paste")

A material produced by grinding glass into a fine powder and then adding a binder to create a paste, a FLUXING medium to facilitate melting, and a coloring agent such as powdered glass or METALLIC OXIDES. The paste is brushed or pressed into a MOLD, dried, and FUSED by heating. After ANNEALING, the object is removed from the mold and finished. Taken from the mold, *pâte-de-verre* has a matte surface that can be polished smooth. It can also be carved to refine the form.

PATTERN MOLDING (see MOLDING)

PEGGING

Using a tool to prick molten glass in order to create small, air-filled hollows. When covered with a second GATHER, the hollows become air traps. See also BUBBLE.

PICK-UP DECORATION

A technique whereby a PARISON is rolled in bits of glass that are usually laid
out on a MARVER. These bits adhere to—are "picked up" by—the hot glass
(see lower figure on p. 58). The whole is then reheated, shaped (using thickly
wadded or folded paper, a BLOCK, or a MARVER), and inflated (see TOOLS).
The glass bits become a decorative embellishment on the surface of the
finished object. Vessels decorated in this manner are often called *splashware*
because the picked-up bits appear to have been splashed across the surface of
the piece. See also BLOBBING.

PIECE MOLD (see MOLD)

PILLAR MOLD (see MOLD)

PINCERS (see TOOLS)

PINCHING

Squeezing hot glass with PINCERS to create a raised pattern (see TOOLS).

PINCHING
The glassmaker created the ridged straps on the figure's uniform by pinching strands of hot glass with a pair of pincers (see TOOLS). Joke glass. H: 34.3 cm (13½ in.), max. W: 9.2 cm (3⅝ in.). Germany or the Netherlands, seventeenth century. JPGM 84.DK.520.1–3.

PLASTIC

Malleable and ductile, that is, capable of being shaped and molded. Glass is plastic when it is in a heated (softened or molten) state.

PLATE GLASS (see WINDOW)

PLATING

An alternative term for CASING, used mainly in the United States during the nineteenth century. Not to be confused with *plate glass* (see WINDOW).

POLISHING

Smoothing the surface of a cooled object by holding it against a rotating wheel fed with a fine abrasive.

PONTIL (see TOOLS)

PONTIL MARK

The irregular round or ring-shaped scar of roughened glass left on the base of a glass object when the pontil is removed (see TOOLS). The absence of a pontil mark on a blown glass piece indicates either that the mark was ground down or that the final shaping of the object was achieved without the use of a pontil.

PONTIL MARK
Bottom of a bottle shaped like a barrel. *The Frontinus Bottle.* Transparent bluish-green glass; MOLD BLOWN. H: 18.3 cm (7¼ in.). Roman, ca. third century A.D. CMOG 62.1.32.

POST TECHNIQUE

Applying a PONTIL to the base or base ring of a vessel being formed with a flat plate of glass called a post. This technique is used in lieu of applying the pontil with a separate wad of glass.

POT ARCHING

The process of heating a new FIRECLAY pot in a separate KILN—a *pot arch*—over a period of at least five days to a temperature sufficient to allow it to be transferred to its position in the glass-melting FURNACE, where it will replace a cracked or worn pot. See also FIRING.

POTASH

Potassium carbonate used as an alternative to SODA (sodium carbonate) as a source of ALKALI in the manufacture of glass. This alkali serves as a FLUX to reduce the temperature at which the SILICA melts in the BATCH. Potash glass is slightly more dense than soda glass; it passes from the molten to the rigid state more quickly and is, therefore, more difficult than soda glass to manipulate into elaborate forms. However, potash glass is harder and more brilliant and lends itself to decorative techniques such as facet CUTTING and copper-wheel ENGRAVING.

POTASSIUM-LIME GLASS

A form of glass containing, usually, 60–75% silica, 12–18% potash, and 5–12% lime. Forest glass—the glass made in rural glasshouses of central and northern Europe in the late Middle Ages and early modern period—is a common form of potassium-lime glass. This glass was FLUXED with POTASH derived from the wood used to fuel the FURNACES and was stabilized by LIME that existed as a natural impurity in the raw materials.

PRESSED-GLASS TECHNIQUE (see MOLDING)

PRISMATIC CUTTING (see CUTTING)

PRUNT

A blob of glass applied to a glass object as decoration. It is thought that these bumps served also to afford a firm grasp on a vessel; this is particularly true in the absence of a handle and when held by diners who might also be eating with their hands during the Middle Ages and the early Renaissance period, a time when forks were not universally used. Prunts could be further embel-

lished with impressed stamps. Their application could also create small round areas for further inflation and manipulation with tools—such as in the case of claw beakers—since the small gobs of hot glass would heat the portion of the vessel directly underneath them while the surrounding area would remain cool and rigid.

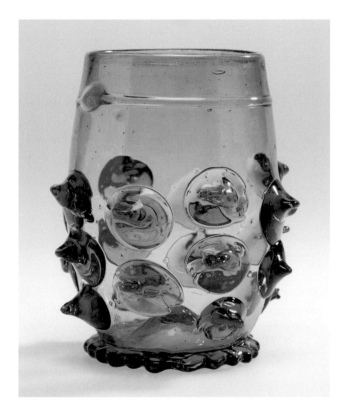

PRUNT
Prunted beaker.
H: 9.9 cm (3⅞ in.),
max. Diam: 8.9 cm
(3½ in.). Germany,
late fifteenth or early
sixteenth century.
JPGM 84.DK.526.

PUCELLAS (see TOOLS)

PULEGOSO (Italian, "bubbly")
A type of glass developed in Murano in the 1920s that is so full of air bubbles that it appears almost opaque. To make it, the BATCH is vigorously mixed with salts. Because of the heat, these salts let off gases that become diffused in the form of air bubbles of varying sixes.

PUNTY (see TOOLS)

RAISED-DIAMOND CUTTING (see CUTTING)

REDUCING ATMOSPHERE

An atmosphere in a KILN or FURNACE that is deficient in oxygen. Sometimes a reducing atmosphere is created intentionally (by restricting oxygen or burning wet fuel) to produce LUSTERS and certain colors. By restricting the oxygen in the furnace, for example, the heat seeks out oxygen in the METALLIC OXIDE pigments and forces them to release their oxygen; reduced to their metallic states, the pigments become IRIDESCENT.

REFRACTIVE INDEX

A measure of the amount that radiation is refracted on passing between two media. For glass, this index measures the amount that glass changes the direction of (or bends) light waves that strike its surface. LEAD GLASS has a higher refractive index (bends light waves more) than SODA-LIME GLASS and, when decorated by cutting, gives a more brilliant (sparkling) effect.

REFRACTORY

A substance, such as fireclay, capable of resisting high temperatures (see CRUCIBLE).

REHEATING

Also known as *warming in*. During manufacture, reheating a BLOWN object at the GLORY HOLE to allow additional inflation and/or manipulation with TOOLS, a process known as *working at-the-fire*. Reheating is also necessary in order to attach handles, bases, and decorative TRAILS without destroying the object through thermal shock.

RELIEF CUTTING (see CUTTING)

RESIST (see ACID ETCHING)

REVERSE FOIL ENGRAVING

A decorative technique whereby gold or silver leaf is applied to the back side of a piece of glass and ENGRAVED; this surface is then protected by varnish, metal foil, or another piece of glass. In French it is called *verre églomisé* after the eighteenth-century Parisian art dealer Jean-Baptiste Glomy, who decorated his frames with such gilt glass, although the technique was developed much earlier, in the thirteenth century. This technique is similar to but distinct from that used to make GOLD GLASS.

REVERSE FOIL ENGRAVING
Reverse GILDED panel with Christ. Colorless nonlead glass; BLOWN (sheet glass), GROZED, reverse GILDED, and ENGRAVED. H: 12.1 cm (4¾ in.). Switzerland (Zurich), ca. 1610–1630. CMOG 87.3.18, gift of Mrs. Ruth Blumka in memory of Leopold Blumka.

REVERSE PAINTING

Painting a design on the back side (often the interior) of a glass vessel. The design is viewed through the glass. Because of this, the pigments must be applied in the reverse of normal order, beginning with the highlights and ending with the background. The technique is also referred to by its German name, *Hinterglasmalerei* ("painting behind glass").

RIBBON GLASS (see MOSAIC GLASS)

ROD FORMING

Molten glass winding around the tip of a narrow metal rod that has been coated with clay or KILN WASH to help the glass separate from the rod. Rod forming is used for making long narrow vessels, such as tubes for kohl; it is also used to manufacture beads and pendants.

ROTARY POLISHING (see ABRASION)

SAGGING (see MOLDING)

SAND

The SILICA most commonly used for making glass. It is collected from the seashore, from riverbeds, or from other deposits. For most present-day glass-making, sand must have a low iron content. Before being used in a BATCH, sand is washed, heated to remove carbonaceous matter, and sieved to obtain uniformly small grains. The Roman naturalist Pliny the Elder (A.D. 23–79) noted preferred sources of sand, citing the Belus River in ancient Phoenicia and the Liternus River in Campania, Italy.

SANDBLASTING (see ABRASION)

SAND MOLDING (see MOLDING)

SANDWICH GLASS (see GOLD GLASS)

SCALE

The accidental inclusion of corrosion products that detach from the metal implements used to stir the BATCH or to form an object.

SCHWARZLOT (German, "black lead")

A transparent sepia-colored ENAMEL with the black appearance of lead, hence its name, that was first used in the Middle Ages for painting lines and shadows on stained glass. *Schwarzlot* was later applied to glass vessels, either by itself or in combination with other enamels or gold. It was often employed by *Hausmaleren*, independent glass and ceramic painters in the seventeenth and eighteenth centuries.

SEEDS

Small BUBBLES of gas trapped in glass. They usually occur in groups.

SHEARINGS

Slivers of waste glass formed during manufacture by trimming hot glassware with shears (see TOOLS).

SHEARS (see TOOLS)

SHOP (see GAFFER)

SICK GLASS (see CRIZZLING)

SCHWARZLOT
Beaker, Silesia,
ca. 1695–1715, probably
painted by Ignaz Preissler
(German, 1676–1741).
V&A C.341-1936.

SEEDS
The small sparkling dots below the rim of this goblet's BOWL are seeds. Goblet (detail),
FAÇON DE VENISE. Possibly southern Netherlands, 1560–1625. JPGM 84.DK.549.

SILICA

Silicon dioxide, a mineral that is one of the essential ingredients of glass. The most common form of silica in glassmaking has always been SAND. Silica is the principal constituent of almost all rocks, and the silica mineral quartz is the principal constituent of most sand. Silica is an extremely hard and strong mineral and normally needs to reach 1700°C (3100°F) in order to melt. Since these temperatures are too high to make glass production economically feasible, a FLUX must be added to aid in its fusion.

SINTERING

The process of heating a mixture of materials to the point that the materials combine (their surfaces melt together) and become a coherent mass, but not to the point that they completely fuse. Sintering is used to produce a FRIT and is sometimes called *fritting*.

SIZE

A name referring to several glutinous materials, such as glue and resin, used to attach color in ENAMELING or applying gold leaf.

SLUMPING (see MOLDING)

SMALT

Colored glass that is finely ground to use in making ENAMELS and as a colorant in glass. The term most often refers to deep blue glass colored with cobalt oxide. In Italian, *smalti* are also tesserae (small cubes or rectangles) of colored glass used for the production of MOSAICS. *Smalti filati* are made by drawing the smalt into threads (*fili* in Italian) from which the tesserae are cut to make micromosaics or miniature mosaics in jewelry.

SNAKE-THREAD DECORATION

A decoration that consists of TRAILS, sometimes multicolored, applied in sinuous, snakelike patterns over the surface of a vessel. Snake-thread vessels were made during the Roman era between the second and fourth centuries A.D.

SODA

Sodium carbonate, frequently used as the ALKALI ingredient of glass. It serves as a FLUX to reduce the fusion point of the SILICA when the BATCH is melted. Soda is present in NATRON and in the ashes of certain plants that grow on the seashore or in saline soils.

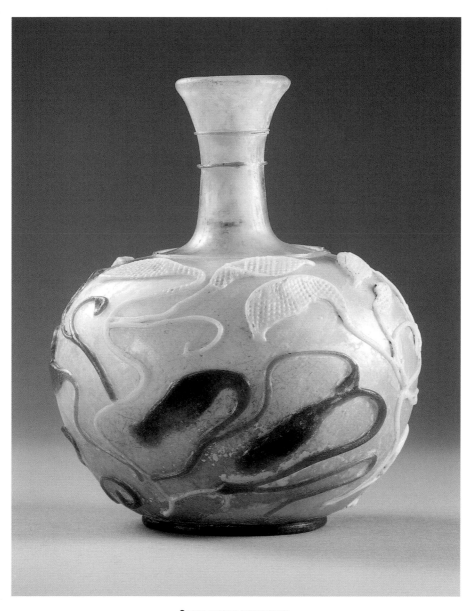

SNAKE-THREAD DECORATION
Flask. H: 14.1 cm (5⁹/₁₆ in.). Roman, third century A.D. JPGM 96.AF.56. Photographer: Bruce White.

SODA-LIME GLASS

The most common form of glass, it contains three major compounds in varying proportions: SILICA (60–75%), soda (12–18%), and LIME (5–12%). Soda-lime glass objects are relatively light and, after heating, stay workable over a wide range of temperatures. They lend themselves, therefore, to elaborate manipulative techniques.

SOFFIETTA (see TOOLS)

SPLASHWARE (see PICK-UP DECORATION)

SPUN GLASS (see WINDOW)

STAINED GLASS

For this roundel, silver staining was used to create areas of yellow and gold that were then modeled with brown paint—STIPPLED with a badger brush, incised with a tool, and enhanced with linear touches—to produce a subtly modeled and dynamic scene. *The Archangel Michael.* Diam: 27 cm (10⅝ in.). Possibly southern Netherlands, ca. 1530. JPGM 2003.73.

STAINED GLASS

The generic name for decorative windows made of pieces of colored glass
fitted into lead strips and set into iron frames. However, the term is mislead-
ing because, in addition to glass colored by STAINING, glass is also colored
throughout by adding METALLIC OXIDE pigments to the BATCH and on the
surface by FLASHING or ENAMEL painting. It is possible that the technique
derives from the Byzantine tradition of covering church walls with glass
MOSAICS.

STAINING

The process of coloring the surface of glass by applying a silver salt (sulphide
or chloride) and then FIRING the glass at a relatively low temperature. The sil-
ver imparts a yellow, brownish yellow, or ruby colored stain that may then be
painted, ENGRAVED, or etched.

STEM (see VESSEL COMPONENTS)

STIPPLING

Tapping the surface of an object with a pointed tool, often with a diamond or tungsten-carbide tip. Each tap produces a mark, and the decorative pattern is made up of many hundreds or thousands of marks. On lacy-pattern pressed glass, the stippling is part of the decoration of the MOLD. See also ENGRAVING.

STIPPLING
Wineglass (detail). Colorless LEAD GLASS; BLOWN, stipple ENGRAVED by Frans Greenwood (Dutch, 1680–1761). Netherlands (Dordrecht), 1746. CMOG 51.2.206, bequest of Jerome Strauss.

STONE

Any nonglassy material accidentally included in glass. Stones consist of un-melted particles of the BATCH, fragments of REFRACTORY material from the pot or the FURNACE walls and roof, or DEVITRIFICATION crystals. Stones of the first two types are usually irregular but rounded; those of the third variety are angular and well formed.

STRAIN CRACKS

Fissures in the body of a vessel caused by internal stress resulting from inad-equate ANNEALING and other forms of thermal shock.

STRIKING

Reheating glass after it has cooled. Striking is undertaken to develop a particular color or to activate an opacifying agent that takes effect only within a limited range of temperatures.

SWEATING GLASS (see CRIZZLING)

SWIRLED RIBBING (see MOLD BLOWING)

TANK (see CRUCIBLE)

TESSERA (see MOSAIC)

THREAD (see TRAILING)

TOOLS

The utensils used to develop and form glass in glassmaking include the following:

A *battledore* is used to smooth the bottoms of vessels and other objects. It is in the form of a square wooden or metal paddle with a handle.

A *bit iron* is a small gathering iron used for collecting smaller bits of glass.

A *block* is a chunk of wood—traditionally apple, pear, or cherry—hollowed out to form a hemispherical or ovoid concavity. It is always kept in water when not in use. It serves to shape a GATHER of glass into a sphere before inflation and is kept wet to reduce charring and to create a "cushion" of steam between it and the hot glass.

The *blowpipe* or *blowing iron* is the iron or steel tube, usually about five feet long, used for inflating glass. Blowpipes have a mouthpiece on one end, and the other end flares out to form a conical shape (the *nose*) on which the glass is gathered.

The *borsella* is a tonglike tool used for shaping glass.

Calipers are an instrument with two adjustable arms that serve to measure diameter or thickness. They help glassmakers copy a given form to create identical or matching pieces in a set or series, such as a table service of glassware.

Used by glassmakers, a *clamp* can be employed instead of the PONTIL to hold the closed end (usually the bottom) of a partly formed glass vessel while the open end (usually the mouth) is being shaped.

A *clapper* is used to squeeze a blob of glass in order to form a foot (see VESSEL COMPONENTS). It consists of two rectangular pieces of wood joined by a leather hinge. One of the pieces of wood has an aperture through which the stem can fit while the other piece of wood flattens the base of the foot. This tool is also known as a *footboard*.

Crimpers are used to impress a crimped or wavy edge on glass.

A *gadget* is a metal rod with a spring clip used to grip the foot of a vessel. It was first used in the eighteenth century to avoid the use of a PONTIL.

The *gathering iron* serves to collect a gob of molten glass at its tip.

A *grozing iron* is an implement used to snap or break away the edge of a glass object.

A *hand press*, shaped like a pair of pliers with flat jaws containing molds, is used to form small glass objects such as chandelier parts, stoppers, and bases.

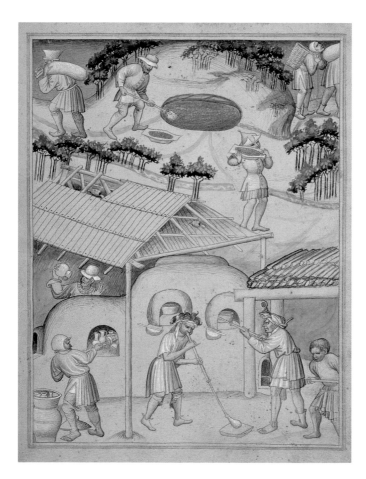

TOOLS
In the foreground, a glassblower inflates a glass BUBBLE on a marver set on the ground; to the far right, a young man stokes the fire; to the left, another man uses a stick to take out finished but still hot objects from the ANNEALING chamber, or lehr. On the other side of the FURNACE, a man sorts through cooled pieces. Beyond the glasshouse, wood ash is being burned and carted away; at the upper right, two men carry baskets filled with glassware to market. From *Sir John Mandeville's Travels* (detail of illustration) (probably Bohemia, ca. 1420–1450). London, The British Library, Ms. 24189, fol. 16v. Photo: The British Library.

Jacks (or *pucellas*) are a tonglike tool composed of two metal arms joined by a sprung section that is used to form the mouths of open vessels. The glassworker's grip controls the distance between the arms. Increasing the distance between the arms when the tool is placed inside the mouth of a vessel increases the aperture, while closing the jacks from the outside of the piece makes the mouth narrower. Jacks are also used to shape stems and feet in particular and to adjust shapes of vessels in general.

Glassmakers use a *ladle* with a large hemispherical metal bowl and a long handle to pour out the hot glass from a FURNACE before refilling, rebuilding, or changing the pot.

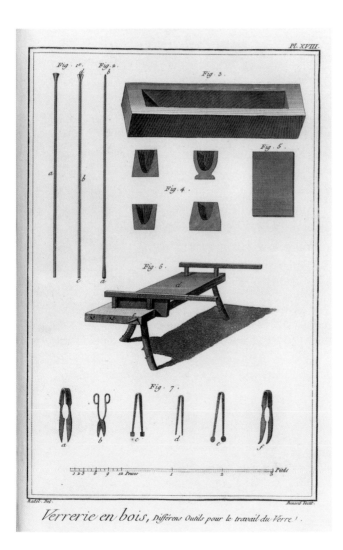

Pl. XVIII.

Verrerie en bois, Différens Outils pour le travail du Verre.

TOOLS
In this illustration, fig. 1 shows a blowpipe (a) and its cross-section (b), fig. 2 is a PONTIL, fig. 3 is a wood box used to collect glass CUTTINGS, fig. 4 is MOLDS, fig. 5 depicts a marver, fig. 6 is a CHAIR, and fig. 7 illustrates various sprung TOOLS such as pincers, shears, and jacks. From Denis Diderot and Jean Le Rond d'Alembert, *Recueil des planches, sur les sciences et les arts liberaux et les arts méchaniques, avec leur explicacion* (Paris, 1772), vol. 10, pl. 18. Los Angeles, Research Library, GRI no. 84-B31322. Photo: GRI.

A *lipper* is a wood instrument in the form of a cone with a handle that is used to shape the lip at the mouth of a vessel.

A *marver* is a smooth, flat surface over which softened glass is rolled or pressed while attached to the BLOWPIPE or PONTIL. This procedure is used to form and smooth the PARISON and to pick up and consolidate applied decoration to the glass surface. The term derives from the word *marble*, since these surfaces were initially made of polished stone. Polished metal such as cast steel or iron is now commonly used.

A *pallet* is the same as a *battledore*.

Paper is a thick mat of damp newspaper large enough to cover and protect the hand and often used with, or instead of, a wooden block, allowing the hot glass to "ride" on a cushion of steam. It is used to shape and to cool the surface of the glass prior to inflation and during the manufacture.

Parrot-nosed shears are a type of cutting instrument used for shearing off TRAILS such as for a handle.

Pincers are a small sprung tool that is used for decorating objects by pinching and pulling the glass while it is hot. They can also be used to remove unwanted bits of material picked up from the GATHER.

Pliers are pincerlike tools used to grip glass to snap off a cut along a scoreline.

The *pontil* (or *punty*) is a solid metal rod to which a hot vessel is transferred from the blowpipe for further working. The PONTIL can hold the vessel when it is attached to the vessel's base with a wad of hot glass.

Shears are the heavy scissorlike tool used to trim away hot glass while it is attached to the blowpipe or pontil.

A *soffietta* is a curved metal tube with a conical nozzle used to further inflate a vessel once it has been transferred from the blowpipe to the pontil. The glassblower reheats the vessel and inserts the *soffietta* into its mouth; the nozzle's conical shape closes off the aperture so that air blown into the tube inflates the vessel.

Individual instruments are also specially made to suit a particular purpose.

TRAIL (see TRAILING)

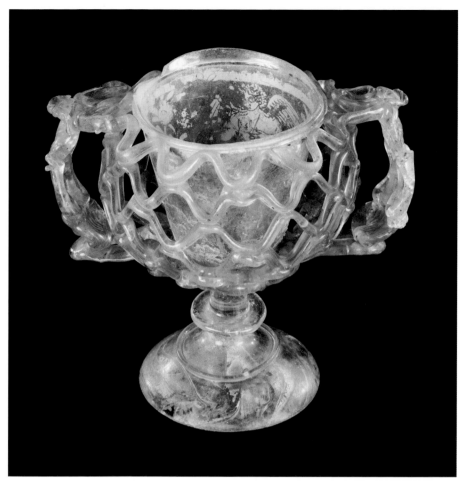

TRAILING

The network of glass that surrounds the interior cup of this vessel was created by trailing a thick thread in a zigzag pattern. *The Disch kantharos.* Colorless glass with a green tint; BLOWN from two GATHERS; decoration GILDED and scratched; cage and handle APPLIED. H: 13.8 cm (5⅜ in.). Roman, third–fourth century A.D. CMOG 66.1.267. (See also illustration on page 57.)

TRAILING

Applying trails (threads) of glass as decoration on the body, handle, or foot of a vessel.

Trail: A strand of glass drawn out from a GATHER and applied to another object; also called a *thread.*

TWISTING (see BUBBLE)

UNDERCUTTING (see CUTTING)

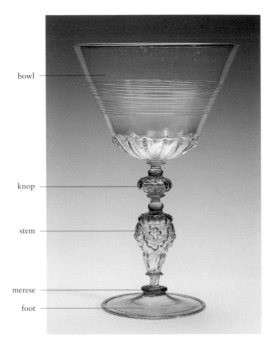

bowl

knop

stem

merese

foot

VESSEL COMPONENTS
Goblet, *FAÇON DE VENISE.* H: 21.3 cm (8⅜ in.), Diam (at lip): 14.0 cm (5½ in.). Possibly southern Netherlands, 1560–1625. JPGM 84.DK.549.

VESSEL COMPONENTS

In addition to a main cavity, or *bowl*, that serves as a container, glass vessels can also include the following elements, which have utilitarian as well as decorative functions:

The *foot* is the portion that comes in contact with a table or shelf, supporting the vessel.

A *knop* is the usually spherical or oblate component of the stem of a drinking glass that, incidentally or not, helps one's hand hold the vessel securely. A stem can include one or a group of knops, which can be placed contiguously or with intermediate elements. Knops can be hollow or solid and can also serve as the finial to a lid. A flattened knop that separates vessel elements—such as the bowl and stem or stem and foot—is called a *merese*.

The *stem* connects the foot to the bowl with a thin shaft that both elongates the form and provides a way to easily hold the vessel.

VETRO A FILI, VETRO A RETICELLO, VETRO A RETORTI (see FILIGREE GLASS)

VETRO ZANFIRICO

Synonymous with *vetro a retorti*, this term is a corruption of the name of Antonio Sanquirico, a nineteenth-century art dealer who helped renew interest in this type of glass decoration.

WARMING IN (see REHEATING)

WASTER

A defective object discarded during manufacture. Wasters are routinely recycled as CULLET.

WEATHERING

A chemical reaction on the surface of glass caused by the environment. Weathering often involves the leaching of ALKALI from the glass by water, leaving behind siliceous weathering products that are often layered and flake off easily. The weathered layer often has an IRIDESCENT appearance.

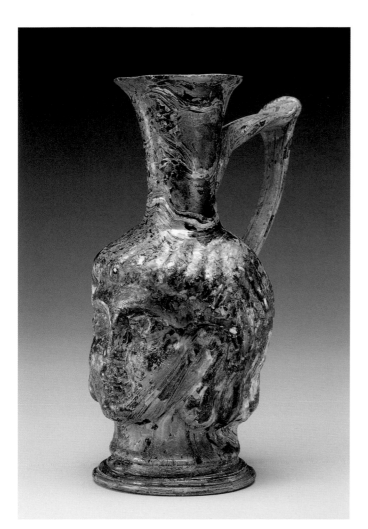

WEATHERING
Head flask. H: 17.2 cm
(6¾ in.). Roman,
fourth–fifth century
A.D. JPGM 85.AF.320.

WEEPING GLASS (see CRIZZLING)

WINDOW

Flat glass for use in windows has been produced since ancient times. Until the nineteenth century, four types of flat glass were made: crown, cylinder, float, and plate glass.

Crown glass, also known as *spun glass*, is created by blowing a PARISON, puntying it (placing it on a pontil [see TOOLS]), CUTTING it open, and rotating it rapidly, with repeated REHEATING, until centrifugal force has caused it to become a flat disk. After ANNEALING, the disk is cut into panes of the required shape and size.

Bull's eye panes come from the centers of disks and preserve the thickened area where the parison was attached to the pontil. Although wasteful of glass and capable of making only small panes, this technique produces exceptionally brilliant and transparent flat glass.

Cylinder glass, also known as *broad glass* and *muff glass*, is made by inflating a large GATHER and then swinging and shaping it to form a cylinder. The end is opened out, the cylinder is sheared along half its length, and it is placed on a pontil. The other end is opened out and the lengthwise shearing is completed. It is then placed in a KILN and allowed to slump and open out to form a flat sheet (see MOLDING). After annealing, the sheet is cut into panes. Although not as clear as crown glass, cylinder glass could be made in large sheets.

Roman glassmakers in the third century A.D. were capable of making panes of glass, called *float glass*, which was cast in molds. Molten glass was poured onto a marver and squashed to form a flat disk (see TOOLS). It was reheated and pulled using pincers to form a square or rectangle. The resulting panes could only reach a size of about two feet square—much smaller than the sizes achieved by later methods.

The casting technique for flat glass became widespread in the seventeenth century with the invention by Bernardo Perotto (active 1647–1680s) of the *plate glass* technique, whereby glass was cast on large iron tables. The resulting large panes had a dull, rough surface and required grinding and polishing to become brilliant and clear. Plate glass was used widely for mirrors as well as windows.

WRYTHEN (see MOLD BLOWING)

ZWISCHENGOLDGLAS (see GOLD GLASS)

WINDOW
The window at the upper right of this scene is filled with bull's-eye panes. Girolamo da Cremona
(Italian, active 1451–1483), *Pentecost*, miniature from a devotional or liturgical manuscript,
Italy (possibly Mantua), ca. 1460–1470. Dimensions: 20.1 × 12.8 cm (7¹⁵⁄₁₆ × 5¹⁄₁₆ in.).
JPGM Ms. 55; 94.MS.13R.

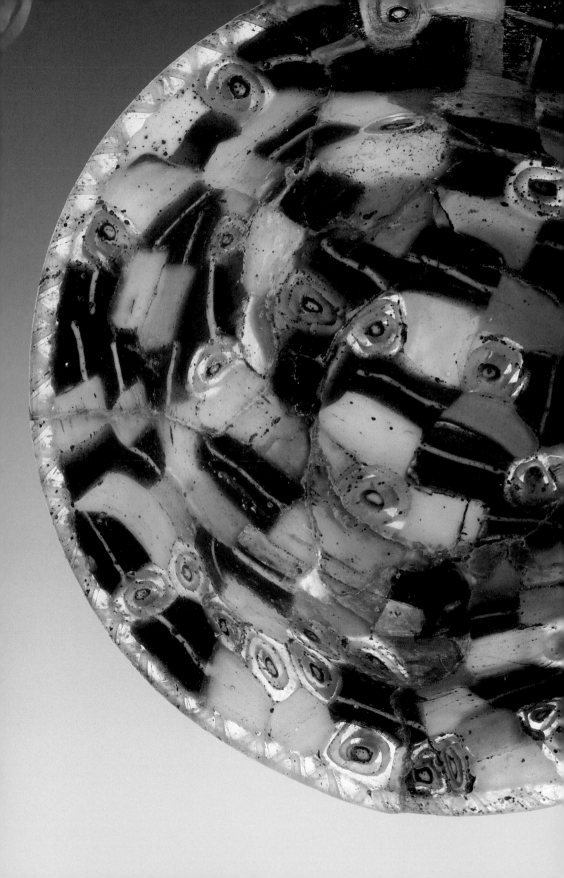

Suggestions for Further Reading

www.cmog.org This Web site contains a complete version of *Glass: A Pocket Dictionary of Terms Commonly Used to Describe Glass and Glassmaking*. Corning, New York, 1993.

KEITH CUMMINGS, *A History of Glassforming*. London, 2002.

DAVID FREDERICK GROSE, *The Toledo Museum of Art: Early Ancient Glass*. Toledo, Ohio, 1989.

DONALD B. HARDEN, *Glass of the Caesars*. Milan, 1987.

CATHERINE HESS, ed., *The Arts of Fire: Islamic Influences on Glass and Ceramics of the Italian Renaissance*. Los Angeles, 2004.

CATHERINE HESS and TIMOTHY HUSBAND, *European Glass in the J. Paul Getty Museum*. Los Angeles, 1997.

REINO LIEFKES, ed., *Glass*. London, 1997.

JENNIFER HAWKINS OPIE, *Contemporary International Glass*. London, 2004.

ADA BUCH POLAK, *Glass: Its Tradition and Its Makers*. New York, 1975.

E. MARIANNE STERN, *The Toledo Museum of Art: Roman Mold-Blown Glass*. Toledo, Ohio, 1995.

E. MARIANNE STERN, *Roman, Byzantine, and Early Medieval Glass, 10 B.C.E.–700 C.E.: The Ernesto Wolf Collection*. New York, 2001.

HUGH TAIT, ed., *Glass: Five Thousand Years*. New York, 1991.

Index

Note: Page numbers in **boldface** indicate main topics. Page numbers followed by the letter *f* refer to illustrations.

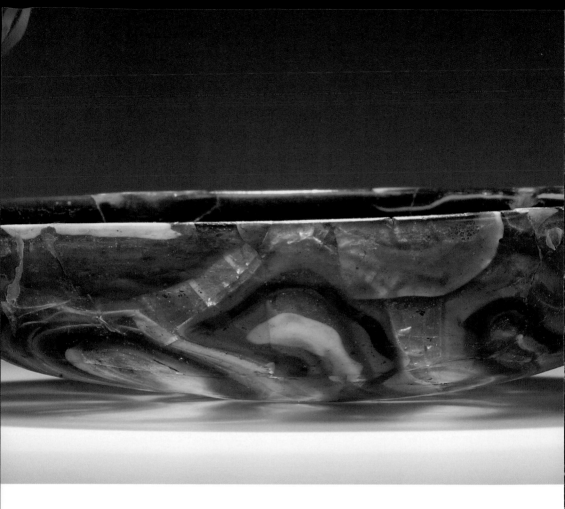

Diane Mark-Walker, *Manuscript Editor*

Benedicte Gilman, *Editorial Coordinator*

ReBecca Bogner, *Production Coordinator*

Kurt Hauser, *Designer*

Columbine Bloodworth, Anthony Peres,
Ellen Rosenbery, and Jack Ross, *Photographers*
(JPGM objects, unless otherwise noted)

Typeset by Diane Franco

Printed by Imago